Successful Syndication

A GUIDE FOR WRITERS AND CARTOONISTS

MICHAEL SEDGE

ALLWORTH PRESS
NEW YORK

04 03 02 01 00 5 4 3 2 1

Published by Allworth Press
An imprint of Allworth Communications
10 East 23rd Street, New York, NY 10010

Cover design by Douglas Design Associates, New York, NY

Page composition/typography by SR Desktop Services, Ridge, NY

"Contract Analysis" by Stuart Rees
© 2000 Stuart Rees

ISBN: 1-58115-051-2

Library of Congress Cataloging-in-Publication Data
Sedge, Michael H.
 Successful syndication : a guide for writers and cartoonists /
 by Michael Sedge.
 p. cm.
 Includes bibliographical references and index.
 ISBN 1-58115-051-2 (pbk.)
 1. Syndicates (Journalism). 2. Newspapers—Sections, columns, etc.
 3. Journalism—Authorship. 4. Cartooning. I. Title.
 PN4784.S8 S43 2000
 070.4'4—dc21 00-025206

Printed in Canada

CONTENTS

ACKNOWLEDGMENTS

There were more people involved in making this book a reality than, I believe, any of my previous titles. I would like to take this opportunity, though, to personally thank three individuals: Angela Adair-Hoy, Linda Davis Kyle, and Stuart Rees.

part 1

GETTING SYNDICATED

REALISTIC EXPECTATIONS

Sooner or later nearly every writer and cartoonist contemplates syndication. And why not? You could be the next Ann Landers, Dave Barry, Dr. Ruth, Gary Larson, Mort Walker, or G. B. Trudeau. Your innovative cartoon strip or weekly column could launch your career to unforeseen heights. You could become internationally famous. Your work could be transformed into a film or televised cartoon series, competing with *The Simpsons*. Licensing and merchandising of books, videos, computer games, audio tapes, toys, and more could have your bank account reeling into the six figures in no time.

Then again, it could all be a pipe dream. But how do you know?

That's the funny thing about many of the best things in life—you never achieve them unless you try. Certainly you've heard people say, "I've got this great book I want to write. It will probably be a best-seller." Well, maybe it would and maybe it wouldn't. One thing is certain, though: If these people never sit their butts in a chair and actually produce that book, we'll never know if they could have been the next Hemingway or Mitchell.

As you explore the fascinating world of syndication, always keep this in mind: You could be that one-in-a-million winner, or you could be one of a million losers. Perhaps the best advice you'll find in this book is right here: Work towards your goal. Struggle for that goal. Fight for that goal. But always be realistic.

A recent report on the publishing industry pointed out that there are about 2,500 nationally syndicated artists (I include both writers and cartoonists here, as both are recognized art forms) in the United States. Your goal should, ultimately, be to make that figure 2,501. The fact that you are reading this book indicates that you are on the road to achieving this goal. For most people, the road is long, windy, and bumpy before reaching the smooth blacktop of the national syndication highway. In getting there, many have taken a back road—and you might also find yourself in a position to do the same.

Ruth Westheimer, the famous "Ask Dr. Ruth" columnist, for instance, gained syndication success after practicing medicine, teaching at Brooklyn College and Columbia University, and writing a series of successful books. Steve Moore, on the other hand, was set on a career in journalism. After receiving a master's degree from Oregon State University, he landed a job as sports editor for the *Maui News,* in Hawaii, and eventually became the executive news editor at the *Los Angeles Times.* For many writers, this would have been the perfect job, but not for the creator of "In the Bleachers," a cartoon currently handled by Universal Press Syndicate.

"I ended up at Universal Press Syndicate . . . [after my] . . . contract with Tribune Media Services was up, so I became sort of a cartoonist version of a 'free agent.' I had always wanted to be with Universal because they have serviced all the legendary cartoons like 'Doonesbury,' 'Calvin & Hobbes,' and 'The Far Side,' so I made the leap."

While only a few thousand artists make it to the peak of the national syndication mountain, many hundreds of thousands are climbing the ladder while making above average livings through local, state, or regional syndication. Turning the work you do for one publication into something that two, three, four, and eventually forty or even four hundred editors want is what syndication, and this book, is all about. My goal is to lead you down the road, pointing out the jagged rocks and potholes so that they can be avoided, making your ride as smooth as possible.

At some point—perhaps even at the onset—you may decide, as many others have, that the best route for you is self-syndication. Writer James Dulley made such a decision several years ago, when he was producing the "Sensible Home" column for a local newspaper. Combining marketing savvy and dedication, Dulley expanded his syndicate to its current four hundred newspapers and thirty magazines. The syndication fees bring him nearly $1 million a year. Spin-off sales—books and pamphlets—bring him another $1 million.

While individual newspapers and magazines pay very little for syndicated material, there is big money in numbers. Imagine, for example, that Ann Landers' column appears in 1,200 newspapers with a daily readership of more than 90 million people. The average three hundred–word column might sell for $4. Multiply this by seven days a week and you have $28. Not much, right? But the folks at Creators Syndicate, which distributes Landers' columns, realize that with 1,200 clients, they will bring in nearly $1.75 million a year.

There is also a celebrity-like power, or status, that comes with being syndicated. You develop a following or, if you prefer, fans. For many artists, this reward is as valuable as the money they earn. When readers begin to send letters to the editors praising them for publishing your work, or criticizing them for not having your columns or your cartoons in their pages, you know that you have truly reached the zenith of syndication. As Dawn Simpson, editor of the *Van Horn Advocate,* wrote to Laid-Back West Syndicate, "Our readers love 'A View from the Porch,' [by columnist Linda Mussehl]. We couldn't stop running it or we would have unhappy subscribers."

Is It for You?

Before spreading your arms and flying to the adventurous world of Syndi-Syndi Land, you must be certain that it's the right direction for your career. While Peter Pan never wanted to grow up, there were others—Wendy for example—that preferred to experience a more traditional lifestyle. The same is true about syndication—it is not for everyone.

Several years ago, I sat in a restaurant in Heidelberg, Germany, with editor, writer, and former syndicated cartoonist Charles Kaufman. Over the schnitzel and Bavarian wine, I asked, "Why did you give up syndication?"

"It began to take over my life," he replied. "I still do my 'Fred and Frank' cartoons for military magazines, but they're monthly—giving me time to breathe. I couldn't handle the stress of daily syndication. Your mind is constantly in this cartoon world. Everywhere you go you are thinking about the strip, you carry a note pad around and jot down ideas. At parties I found myself looking and listening for anything and everything that could be developed into visual humor."

Kaufman's words echo the nightmare of many former syndicated artists. For them, the seemingly endless task of creating a column or cartoon strip day, after day, after day becomes a labor of horror, rather than one of love.

Working as a syndicated artist, in general, is hard, long, and demanding. It can take over your life, as Kaufman put it, leaving you with little time or energy for family, friends, or outside interests. If you succeed, it becomes a business, complete with multilevel contracts, lawyers, and meetings. If you fail, it could discourage you in such a way that you'd change career fields forever.

Because daily or weekly syndication requires such dedication, your first consideration should be your topic. When Johnny Hart sat down in 1958 and began to doodle cavemen, little did he realize that he would be sleeping with "B.C." characters for the rest of his life. But Hart, like most of today's successful syndicated artists—writers and illustrators—was in love with his craft and his subject. He had no choice in what he was doing. Cartoons were what he was all about.

"As far back as I can remember, I drew funny pictures which got me in or out of trouble, depending on the circumstances," Hart says. "The comic strip field is an exciting one. It principally is made up of people who have refused to grow up and who offer marvelous fantasies to those who wish they hadn't."

This is the attitude you must have towards your topic to be successful. It must keep you up at night, thinking, while others are soundly sleeping. While driving, you must find yourself pulling to the shoulder of the road to jot down notes for your next column or strip. There must be a burning passion that, in many respects, matches that of a love affair. Only with such a foundation can syndication become a driving force in your life.

Let's imagine that you've developed a passion for a certain topic, a character, or a situation. The idea is new—i.e., very little or no direct competition—and it has wide audience appeal. You feel this subject could be the key that opens the door to syndication success. But, once again, you must ask yourself, Is syndication for me? And herein lies the problem: If you have never written a syndicated column, or created a syndicated cartoon, how will you know whether or not you can cope with the lifestyle required for such a job?

Perhaps the best way—which will be discussed in greater detail in later chapters—is to begin locally. Working with a single newspaper provides an excellent training ground for potential syndication. The work that goes into a nationally distributed column or cartoon strip is the same required for a daily piece in a local paper. It therefore goes without saying that if you can handle the workload and maintain your enthusiasm on a small scale, you'll have no problem expanding your efforts to national or international levels.

If you find that daily output is just too much—and there is no embarrassment in this realization, as many of the top syndicated artists cannot keep the pace of twenty-four-hour production—try obtaining weekly or monthly commitments from editors in your area. Several years ago, I was thrilled when a regional newspaper offered me one page to fill each day. This was my big break, so I thought. One year later, in fact, I knew it *had* been my big break—break in social life, break in friendships, and nearly a break in my marriage. Daily production was just too much for me.

Using the work I'd done for the newspaper, I found a home for my column in a regional magazine. Having to create only one piece every thirty days, I suddenly found myself with more freedom than needed, or desired. I therefore offered the publication a second column, written under a pen name. Eventually, I was producing three columns a month for the editor and maintaining a normal lifestyle.

Through trial and error, I had discovered what was and was not right for me. My next goal was to expand the network of clients that would publish, and pay for, my columns—that is, to begin syndication. First, however, I had to investigate the national marketplace to insure that my product was right for the audience.

The Marketplace

Often, the careers of talented cartoonists and writers are held back by the fact that they consider themselves "artists." While there may be justification in such self-classification, successful syndication requires that one have business savvy as well as talent. You must be a marketer. You must know what niches are open and what editors are seeking at any given moment. In short, you must intimately know the marketplace.

In their guidelines to contributors, Tribune Media Services, one of the largest syndication operations in the United States, points out that "Some of the most successfully syndicated artists today were rejected early in their careers. . . . The rejected work that you . . . create may be journalistically perfect. A syndicate may turn it down because of poor market conditions in publishing."

What does this mean? Very simply, that you did not study the marketplace and, therefore, presented material that: a) duplicated that which is already being syndicated; b) has a subject or style that focuses on a narrow segment of the market—too narrow for a syndicate to take interest; c) has such an outlandish concept that it is not of interest to the general public. Large syndication operations, such as King Features, receive hundreds of proposals each week for "Dear

Abby"-like columns. The problem is that "Dear Abby" and "Ann Landers" already exist. So why would a newspaper editor pay for another? There are also hundreds of artists that will propose cartoons and columns dealing with narrowly focused topics, such as beavers in Ontario. While this may be good for a local or even regional newspaper, there is little national or international interest in these furry creatures—even when they make you laugh. Finally, there is that rare breed of very talented people with concepts that the general public does not appreciate, and neither do syndication editors. Let's take our beavers as an example. A cartoonist—and readers of *Hustler* magazine—might find humor, with the right cutline, in seeing one of these creatures being caught by the head in a trap. A majority of North American newspaper readers, however, would find horror in this scenario.

So, once your work is editorially perfect—if such things exist—the next step is to insure that your marketing skills are just as sharp.

There are over 1,500 daily newspapers in North America, and an additional 3,500 regional papers published weekly or monthly. These must be added to the thousand or so special interest newspapers such as *Antique Week* and *Cycle News,* or *Nashville Business Journal* and *Tae Kwon Do Times.* Religious newspapers in the United States alone number around two hundred, ranging from the *Presbyterian Outlook,* in Richmond, Virginia, to the *Jewish Reporter,* located, ironically, in Las Vegas, Nevada. And don't forget the many thousands of magazines released each month, as well as international publications. All of these are potential buyers of syndicated material. All of these make up the "syndication" marketplace, but not necessarily "your" marketplace.

As an artist, your marketplace consists of people—the general public that purchases these publications each day, each week, each month to read or view your work. It is a market of millions, and the greater your share, the more your work will be in demand by the acquisition editors of syndication agencies.

Most artists think that marketing a column or cartoon is simply a matter of looking up syndication agencies in directories like *Editor & Publisher Market Guide* and sending their work. In reality, this is not marketing at all. It is merely "cold" submitting. Getting a syndication agency to handle your work is a sales job, requiring a sales strategy. For this reason you must take off your "artist" cap and replace it with a "business" hat.

Imagine you're an executive for, say, Microsoft. You've been asked to sell a new product—in this case, a column or cartoon strip.

There will be several steps and considerations in your marketing strategy, including the demographics and genre of the target market, the competition, production, packaging, distribution, and accounting. The syndication agency, in this pecking order, falls into fifth place. They are the distributors, nothing more. They maintain the sales staff and coordinate activities between the producer (you) and the buyer (global newspapers and magazines). Everything else is your responsibility.

In order to receive a contract from a syndication agency, you must convince the acquisition editor that there is a market for your idea. You must study the competition and come up with comparisons: How is your column or cartoon different, new, fresh? Is your product for a vast audience or a niche segment? How many newspapers do you anticipate would accept your work and why? How fast can you produce new material—daily, weekly, monthly? Do you possess the proper equipment and know-how to provide the necessary formats for today's fast-paced syndication? Do you operate as a business that can invoice for money owed and, at the same time, maintain proper records for tax purposes?

All of these factors contribute to the selling of your work, and it is important that you understand from the onset that there is more to syndication than merely submitting articles or art—that is, naturally, if you intend to be successful.

Mark Tomasik of Scripps Howard News Service put it this way: "Figure out the market and create for the audience's taste."

These words are "golden." Knowing the market for which you are creating is the single most important factor that lands writers and cartoonists contracts for syndication. You must understand how this market thinks, know the conditions under which they work, know their lifestyle, their family status, whether or not they frequent particular clubs or shop at certain stores. The more you know about this market, the easier it will be to convince acquisition editors that you are the right person for their next syndicated effort.

Assuming you already have an idea, sit down, right now, and answer the following questions:

- What is my target market?
- How large is the marketplace?
- Where do individuals within the market work?
- Where do they shop?
- What do they do on Friday night?
- What do they read?

Now let's imagine that your idea is called "Shop Talk." If you're a writer, it might be a humor column based on gossip that circulates in factories across the country every day. If you're a visual artist, your box cartoon might depict humor in the workplace. In either case, your answers might look something like this:

- What is my target market?
 Factory workers and their families in the United States.
- How large is the marketplace?
 62 million, according to the National Labor Union.
- Where do individuals within the market work?
 68 percent in the automobile or related industry, 27 percent in small, independent factories, 5 percent in private industry.
- Where do they shop?
 Primarily K-Mart, WalMart, J.C. Penney's, and similar "economy" outlets.
- What do they do on Friday night?
 Stay home, watch television, go bowling, or go to a restaurant.
- What do they read?
 Mainly the sports and entertainment pages of the local newspaper.

Knowing the answers—truthful answers—to the above questions will illustrate to an editor that you thoroughly know "your" market. Similarly, the style and content of your work should reflect this knowledge—it should target the market. If you can do this, you are already on the road to success.

Rejection/Pitfalls

There is a general misconception that when you are contracted by a major syndicate, some sort of spontaneous combustion takes place, igniting editors' fires throughout the country, and within weeks, your work will be read by millions. This, I can assure you, is mere smoke. Most writers and cartoonists—even those handled by the largest agencies—struggle to get their work picked up by twenty or thirty newspapers. An agency will generally continue to handle an artist's work as long as their sales staff can maintain a steadily growing list of buyers. While they are all willing to take on new material—considering it's good and fits a market—few will waste their staff's time on material that is consistently rejected by newspaper editors.

One must, therefore, learn to live with rejection; it's part of the game. King Features, for example, receives more than six thousand

submissions annually. From these, three—yes, I said THREE—are chosen for syndication. Similarly, Tribune Media Services gets about five thousand proposals during the course of a year. The editors there launch two dozen new features in that same time period.

The key to winning at the syndication game, therefore, is not to let rejection get the best of you. As a member of King Features said, "It simply means that at the time we saw your work, we didn't feel that newspaper editors would buy your feature."

Gary Larson, author of the overwhelmingly successful cartoon, "The Far Side," pointed out in an open letter on the Creators Syndicate Web site that being a syndicated artist ". . . is a very scary, risk-laden proposition. But if there were ever an axiom to follow in this business, it would be this: be honest to yourself and—most important—respect your audience."

The audience should always be foremost in your mind and in your work. Don't write or draw for the editors, but for the potentially millions of newspaper readers. As I pointed out earlier, creating a following, an army of fans, can be just as rewarding as the financial benefits that successful syndication can bring.

A common pitfall for many newcomers is their determination to take on the big agencies and newspaper syndicates. Chuck Sheperd, author of the column, "News of the Weird," distributed by Universal Press Syndicate, suggests that one might avoid rejection and make more headway by concentrating on smaller newspapers and better quality work.

"The key to syndication," says Sheperd, "is to identify a need that newspapers have and fill it, rather than coming up with a 'great idea,' be a 'great writer' [or cartoonist]—writing a better column [or strip] than incumbents. Also, since there are more newspapers in small and medium-sized towns than in big cities, find a need of those readers, rather than those of New York and other big city readers."

This is excellent advice from a man that made his way into the world of syndication through a local newspaper and quality work.

"I broke in by unconventional means, in that the syndicate saw my work in a local weekly newspaper in its hometown of Kansas City, Missouri, and asked me for samples."

2

FINDING A
SYNDICATION AGENCY

F inding the right syndicate "partner" for your work can often be a lengthy process. I highlight the word "partner," because that is exactly what syndicates are. You provide the concept, the talent, and the product, while syndication agencies bring in the marketing skills and staff needed to get your work in front of the editors and into newspapers, magazines, and electronic media throughout the country and the world. If successful, it can be a happy and profitable venture for all. On the other hand, if you team up with the wrong outfit, it could be an utter failure, leaving you bitter towards the entire industry.

It is, therefore, very important that you investigate syndicates before arbitrarily submitting any work. As a young writer, I failed to do so prior to sending several samples of my work to a company in California. I was thrilled when they accepted me as a client. As weeks turned to months, however, no contract arrived. My inquiries also went unanswered. In the meantime, I received calls from friends and relatives saying they'd read my features in various newspapers across the country.

To make a long story short, I received neither contract nor payment from the syndicate. Upon investigating further—something I should have done previously—I learned that several artists had fallen into the same "trap" as I and were taking legal action against the company. The syndicate ultimately filed for bankruptcy, leaving us with no money, but a well-learned lesson.

Where to Begin

Nearly every successful syndicated artist I've spoken with agrees that you should find your niche before seeking a syndicate. But what exactly does this mean—find your niche?

Let's imagine that you have a passion for flowers. Your friends continuously admire your "green thumb" ability. Whenever time allows, you are cultivating orchids, bluebells, roses, and the like. In this case, an advice column on flower growing could be your niche.

Or let's say you are a cartoonist working full-time in a fast-food restaurant. You know the burger business, as well as what goes on behind the scenes. Your niche could easily be a comic strip—perhaps titled "Bay Burgers"—in which you make fun of America's fast-food culture or create comical situations with the personalities working in this environment.

An excellent example of "finding one's niche" is the syndicated radio program, "Car Talk," and its newspaper column spin-off, by Tom and Ray Magliozzi. Commonly called "Click and Clack, The Tappet Brothers" (and thus their column titled "Click and Clack Talk Cars"), Tom and Ray were mere mechanics in Boston in the mid-seventies. By dumb luck and a keen ability to pinpoint and fix the problems of customers' automobiles, they stumbled into a local radio program in 1977 that was ultimately picked up by National Public Broadcasting. (Today it is heard on more than 450 NPB stations nationwide.) Twelve years later, the Magliozzis decided that if their radio show filled a need, or niche, then so should a syndicated column based on the same format.

"In 1989 we launched a twice-weekly newspaper column called 'Click and Clack Talk Cars'," explain the brothers in their biography. "Today, we're single-handedly lowering the standards of more than three hundred newspapers around the country. The column is a lot like the radio show, meaning we take questions and espouse all kinds of solutions—a small fraction of which may actually be correct."

From grease monkeys to syndication gurus, the Magliozzi brothers found a niche based on their knack for humor and mechanical skills and turned it into a money-making syndication venture.

If each newspaper pays only $5 for the Magliozzis' column, that's $40 per paper per month. Multiply that by three hundred newspapers, and their efforts are bringing in $12,000 a month, or $144,000 a year. Even if split 50/50 with the syndicate—in this case, King Features—the authors take in $72,000 a year from this venture.

While it would be nice to follow in the footsteps of "Click and Clack"—no matter how greasy the path may be—your chances of

landing a radio talk show that is picked up by National Public Broadcasting and turning it into a syndicated column or cartoon is probably somewhere just below winning next week's $75 million lottery. So how do you go about finding your own syndication niche? Something that both syndicates and a wide audience will take interest in? The editors at Tribune Media Services suggest the following:

- Read a variety of newspapers, large and small, from all regions of the country. While doing so, ask yourself: What kind of syndicated comics or news copy are they using? Then ask what kind of unique information you can provide. Do you have an expertise? Do you have a hobby that would interest a broad audience?
- After you've identified an opportunity, review *Editor & Publisher* (see appendix E for contact information). This weekly trade journal has a regular report on syndication and creators. If you subscribe, you'll also get the annual *Editor & Publisher Directory of Syndicated Services* published each summer. When you review these publications, note if your idea is already in syndication. If so, you may want to reconsider or refocus the concept, making it new or different in some way.
- Cartoonists would be wise to check out *Cartoonist Profiles,* published quarterly (see appendix E for more information). This magazine offers features on creators of comic strips and box cartoons, how-to guides, and trend stories about syndicates, cartooning, and education. You can also review *Suite101.com,* one of the finest Internet sites available on the state of syndicated cartooning.

In addition to knowing what columns and comics are currently being produced and which syndicates are distributing them, you should research what traditional cartoonists or columnists are on the downswing—i.e., losing relevance and clients. This might indicate an opening at a syndicate, as they often line up new talent as the work of old clients begins to fade. Look also for a trend or change in society that creates a new demand for your information. You might read, for example, that pet owners spend over $14 billion a year. This would indicate a potential market for a column on exotic animals or, perhaps, a cartoon strip based on veterinary services.

Timing is often a key factor in placing your work with a syndicate. In the mid-seventies, many editors turned down ideas dealing

with computer technology. Why? Because the home-computing boom had not yet begun. The 1980s, however, saw a change in media habits, creating a computer craze that not only continues to this day, but has also expanded to include the overwhelming global interest in the Internet. Because of this trend, syndicates, over the past decade, devoured columns dealing with computers, technology, and the Internet. The market, as I write this, is now saturated, and these topics are on the "Most Unwanted" lists of many agencies.

So, in addition to finding a topic that is right for you, you must also keep the audience and trends in mind, as pointed out in chapter 1.

Knowing the Agency

After finding your niche, the next step is to discover the open niches of the syndicates. Why is this so important? Think of it this way: The syndicate business is a large puzzle. Each artist represents one piece of the overall business, or puzzle. If you send material that is the same or similar to one of the artists they already represent, you are basically seen as a piece of the puzzle that is already filled—you are in excess. On the other hand, if your idea offers wide audience appeal and is unlike anything they currently handle, you are viewed as a new and precious piece of the puzzle.

Editor & Publisher magazine and the Internet are extremely valuable tools in learning syndicate needs—if you know what you're looking for. While the first provides straight-forward input—i.e., a cartoonist is leaving XYZ Agency, or a successful columnist has moved from syndicate A to syndicate Z—the Internet offers hidden knowledge about agencies, including insight into the overall clientele, type of material handled, and the likes and dislikes of editors.

The Net has become a major marketing tool for syndicates. On their Web sites, agencies provide an array of information, including the display of client's work, company background, samples, artists' biographies, rates, contributors' guidelines, and more. Creators Syndicate, for example, has page after page of valuable information at its site, *www.creators.com,* including feedback from some of its top writers and cartoonists, like "The Far Side" artist Gary Larson.

You, as a potential client or partner, can utilize this knowledge to your advantage. The first consideration is to review all the current offerings of the company. What you are looking for is anything that even vaguely resembles your idea. If you find something, that is probably a good indication that that piece of the puzzle is filled, and you should move onto another syndicate.

If you find that there are no competing columns or cartoons, ask yourself why? Is your idea so unique, so new, that no one has thought of it? That's what we'd like to think, but let's be honest. You may discover that the concept truly is rare and fresh. If so, great. On the other hand, you may realize that it is overly done or that the market is so small that syndicates simply do not see a profit in handling this type of material. In this case, you may need to come up with a new niche idea.

Generally, syndicates like to handle material that they know how to sell, just as McDonald's might add a veggie-burger to their menu to capture the non-meat-eating market, but would never consider selling swimwear. Some agencies specialize in news features, financial articles, or material dealing with education. Others work only with comic strips and box cartoons. It would be a waste of time, therefore, to send them material that does not fit these formats. Reviewing the overall type of material a syndicate offers will insure that you do not make fruitless submissions, saving you both time and money.

Also consider the type of exposure a syndicate gives its artists. In the same way that your current activities—books, articles, exhibits, etc.—can lead to syndication, having a syndicated feature can frequently result in new opportunities. For this reason you want an agency that not only works to sell your material, but also provides you with exposure, whether it be on its Web site, in its editorial packages, or through its own public relations/marketing efforts. Getting your name and talent in front of millions of potential buyers—book editors, TV producers, comic book publishers, etc.—can often be more valuable for your career than the money you make from syndication.

Some of the questions you should ask are:

- Does the syndicate promote its artists on TV and radio talk shows?
- Does each artist get a page or more on the syndicate's Web site? If so, does it include a biography and photo?
- What other venues would my feature fit into—books, TV, merchandising? Does the syndicate have a department that negotiates these sales?
- How much "special attention" might I get from this agency?

In most cases, if you are successful in placing your work with a syndicate, the answer to this latter question, beyond the initial launch, will be none. That, unfortunately, is the reality of the syndication

game. Most companies have a budget to introduce a given number of new columns and cartoons each year. If, during this initial phase, the feature shows promise, they might invest more for a larger campaign.

As pointed out by Sarah Zupko, senior producer at Tribune Media Services (TMS), in her guidelines to contributors, "Syndication to the national daily newspapers has never been more challenging as newspaper editors grapple with reduced news holes and tighter financial budgets. TMS receives about 100 submissions from writers and creators every week, or 5,000 annually. TMS launches about two dozen new features each year."

To overcome the odds of rejection, as well as get a better career showcase, many artists are focusing their submissions to the smaller syndicates, such as the Texas-based Laid-Back West. While the competition is still tough, it is not so overwhelming as that of the large, global agencies. Additionally, smaller agencies frequently work closer with their artists, developing personal, one-on-one relationships—something large outfits rarely have the time or desire to do.

The Approach

Because major syndicates receive hundreds of submissions each month, you'll want to make yours stand out. Despite a general misconception by some writers and cartoonists, this does not mean that overly elaborate notebooks and binders are the best way to approach a syndicate. Truth is, a simple folder presentation is preferred by most editors. Mailing submissions, by first class mail, is also fine. Unless a syndicate editor requests an overnight delivery, you can spare the expense.

You should, however, address a specific editor by name for faster results. Tell him or her, in your cover letter, if this is your first submission, a resubmission, or a referral. Also tell the editor why you chose their syndicate—i.e., based on your research and review of the agency.

I asked one successful cartoonist how he broke into the business and was surprised to learn that he got his foot in the door through a referral.

"I'd sent my portfolio to several syndication houses," he explained," only to be rejected by all of them. The following week, I was having lunch with a friend, who was also a columnist with Universal Press Syndicate (UPS). After listening to my tale of woe, he suggested I contact a new editor at UPS. He then proceeded to pick up a pay phone and call the editor to inform him that I'd be sending a package. Three weeks later, I was invited to UPS for a meeting. The rest is history."

If it worked for one syndicated artist, it will work for others. So, if you have contacts in the syndication business, use them—even if it is only a receptionist. If not, try to develop them. They may prove to be the key to your success—or at least get you serious consideration.

The Cover Letter

A good cover letter, like a book cover, is a sales pitch. It should include an overview of your relevant artistic experience: art projects, exhibitions, books and publications you've written for in recent years. (I prefer to provide this information on a separate page, to maintain the best display.)

Because syndicates enjoy working with experienced as well as talented artists, they look for indications of this in an introduction letter. For example:

- Have you illustrated or written a book? A syndicated column and a book can enhance each other.
- Do you write or edit a newsletter in your field? Some syndicates seek newsletters that can add another dimension to material that can't appear in the column.
- Do you give talks or are you a speechwriter or researcher? The lecture circuit is a good place to gather column material and mention your syndicated work.
- Beyond print, do you have broadcast experience? Hundreds of newspapers offer audiotex news and information via a Touch-Tone™ phone.
- Do you have online experience? Many newspapers offer news and information via their own online service or commercial services. Several major syndicates and their artists provide news and entertainment to numerous online services and Web sites. E-mail is also a popular way to involve news-paper readers in your comic or column. You'll likely receive spontaneous feedback, positive and negative, via e-mail.

Other information that should be included in your cover letter is a brief description of your feature, the target audience, the competition, and how your work is different. Suggest sections or locations in the newspaper or publication where your work might best be positioned—the sports pages, the political pages, the finance pages. Answer the question: What's the hook? That is, what will make readers stop and view your work? Why will they be interested?

In the movie business, the sale of a script frequently begins with a "logline" pitch to a producer. This is an overview, in two sentences or less, of the story. The same concept should be used in your presentation to a syndicate editor. He can then utilize this in his own delivery of your work to his colleagues. Ultimately, the sales staff will also use the summary to sell newspaper editors on your feature.

It should go without saying—but I'll say it anyway—that your letter should also include your address, fax number, e-mail, and day and evening telephone numbers.

"Generally," explained a Tribune Media Services editor, "you should not call to confirm arrival of your submission. If you don't trust the U.S. Postal Service, you may include a stamped, self-addressed postcard that the syndicate can mail back to you. Most syndicates will give you some idea how long the review process normally takes. TMS usually requires forty-five to sixty days from receipt. Submissions are reviewed by an editor, who typically responds with a letter."

If the consideration process takes so long, it seems only natural that an artist should send his work to more than one agency at a time. This is commonly called "simultaneous submissions." Will such a practice create any difficulties, however, if a syndicate decides to work with you? I posed this question to the folks at TMS, to which they answered, "Some creators send out simultaneous, multiple submissions to other syndicates. Editors appreciate a brief note if it is a multiple submission, but it's not required."

In most cases, replies to submissions come in the form of a polite rejection slip or form letter. There are times, though, when an editor will call an artist to say that the idea is marketable, but needs a different approach. In such cases, a concept goes into a phase called "development." This is when ideas are worked and reworked into perfection. Because syndication is a collaborative process—between you and the agency staff, with input from the editorial, sales, licensing, and promotion departments of the agency—development time can stretch from a few months to a year or two at some syndicates.

Submission Formats

While each syndicate has its own submission guidelines and preferred formats—examples can be found in chapter 4—there are some requirements common among most agencies. A few of these are listed below. I would highly recommend, however, that you obtain a copy of the guidelines for each agency you are considering prior to submitting any work. These can normally be obtained on the syndicate's Web site or by writing for a copy (see appendix A).

Among the general submission guidelines are:

- Do not send original material.
- Send sufficient material to cover one month of features—
 i.e., four columns (normally six to seven hundred words
 each) for a weekly syndicate, twenty-eight strips for a daily
 syndicate, etc.
- Submit only by mail, not fax or e-mail.
- For a cartoon or comic strip, include a written overview of
 the characters and how they relate to each other. Drawings,
 generally, should be in black ink on white paper, with
 shading in ink wash, Benday®, or other dot-transfer.
- Your name and column or cartoon title should appear on
 each work.
- Most syndicates do not have specific sizes for cartoons or
 comic strips, but prefer drawings to be twice the printed
 size—that is, the size in which it will appear in newspapers.
 A standard 8½″ × 14″ sheet of paper is sufficient and makes
 mailing easier.
- For column submissions, always send printed text, not
 disk. Pages should be numbered and double-spaced. On the
 upper left-hand side of the first page, or title page, should be
 the author's name, address, and telephone number. On
 the upper right-hand side should appear the author's
 copyright—i.e., © Michael H. Sedge.
- Tearsheets should be included if the column you are
 proposing has already been published.
- Always include a self-addressed, stamped envelope sufficient
 in size and postage for the return of your material.

3

WORKING
WITH A SYNDICATE

F ar too often, the excitement of getting accepted by a syndicate and the anticipation—as unlikely as it may be—of becoming the next Gary Larson or Dave Barry blurs one's better judgment when it comes to contractual decisions. More than twenty years ago, the Cartoonists Guild put together a booklet called *Syndicate Survival Kit*. In it, they explained the thrill of working with a syndicate and the way such emotion can mislead an artist.

"The temptation to sign a contract, even one . . . completely and obviously unfavorable to the artist . . . must be strong indeed. An artist works for many months on an idea with only one goal in mind—to have it published and seen by the rest of the world. It's an ego trip that must be fulfilled, very often at all costs!"

All the employees at a syndicate, from the editors to the legal department, are aware of the heightened emotional state an artist experiences when he gets a call or letter accepting his work and will often use this to their advantage. In short, they prey upon the writer or cartoonist at his most vulnerable time.

Unlike selling a magazine article or a single cartoon to a local newspaper, a national syndicate has the ability to develop the career path you will be following for the rest of your life—or at least for several years. Take, for example, Charles Schulz. When he first developed "Peanuts" in 1950, little did he realize that he'd be drawing the round-headed Charlie Brown and his black-and-white beagle for the rest of his life. Schulz's cartoon characters went on to become a series

of television specials, books, and an array of merchandising products, from lunch boxes and notebooks to T-shirts and dolls. These long-term considerations are merely one aspect of a syndicate contract the artist needs to consider.

Stuart Rees is an attorney—perhaps the only attorney—specializing in the representation of syndicated cartoonists. He also maintains Stu's Comic Strip Connection *(www.stus.com),* one of the most comprehensive Internet sites for cartoonists and the business of syndication. I highly recommend that anyone thinking about syndication, whether you are a writer or a cartoonist, review this site. In particular, review Rees's 120-page "Thesis on Syndicate Contracts," originally written in 1997, while he was at Harvard Law School, but now updated to reflect his dozens of contract negotiations as a lawyer. The paper can be downloaded free of charge from the Web site or ordered in printed form for $13 (printing and postage charges) from: Stuart Rees, 5 Bridle Path Road, Andover, MA 01810.

When I contacted Stuart, he had just completed his twentieth syndicate deal in an eighteen-month period. And he did it, as he pointed out, "without even trying to find a client."

Rees indicated that too few artists seek assistance from an attorney in their negotiations. Cartoonists and writers, he said, routinely sign terrible deals that last for ten to twenty years. These types of contracts can ruin an entire career.

"The syndication business relies on its five to ten blockbuster comic strips [or columns] for most of its profit," Rees explained. "In particular, their blockbuster comic strips [and columns] create the licensing opportunities from which one-half to three-quarters of a syndicate's revenues are derived. Not surprisingly, each syndicate crafts its contracts with new creators so that the syndicate can capture a sizable amount of the profit should the new feature become a blockbuster."

He goes on to point out that "although best described as intermediaries, the syndicates actually drive the entire process, because they provide direct services to all three of the main industry participants: the creators, the newspapers, and the licensees. For the creators, the syndicates handle all of the business aspects associated with developing, marketing, distributing, and administering the comic [or column] property. This includes selecting the bidders, determining price [and all other terms], evaluating licensing opportunities, editorial supervision [often including some training], production, contracting, art design, billing, collection, accounting, reporting, and some legal services. This set of services can be very expensive,

although the appropriate allocation of these costs among features generates considerable debate, as does how effective the syndicates are at each function."

It, therefore, would seem that every writer and cartoonist getting into the syndication business should have a good lawyer who knows the business. The unfortunate truth, however, is that not all creators can afford such services and, therefore, must rely on their own ability to understand and negotiate contracts. For this reason, Stuart Rees agreed to offer a clause-by-clause critique of a boilerplate contract used by Universal Press Syndicate. A copy of this contract, and Rees's review of the agreement, can be found in appendixes B and C. The review will provide you with a basic understanding of the various features of a syndication agreement, as well as offer suggestions on modifications that you should consider/request.

"The contract analysis walks the reader through a 1997 version of Universal Press Syndicate's contract," said the Boston-based lawyer. "This contract is compared and contrasted to signed contracts sent by creators from Universal and other syndicates."

Syndicates normally do not openly offer their contracts to review, and you should remember that the one in the appendix is merely Universal's boilerplate offer—that is, a first draft. Stuart points out that Universal and most other syndicates will negotiate from this in a fair and reasonable manner.

Studying the agreement, in tandem with Stuart's analysis, will make you aware of some of the major considerations, or issues, that are the foundation of a good syndication contract: bargaining power, fairness, artistic control, business pressures, enforcement, and power from noncontractual sources.

A Realistic Look at the Financial Side

Acceptance by a syndicate is just cause to celebrate. It does not necessarily mean, however, that you will soon be rolling in riches. Truth is, unless the sales staff is successful in placing your column or strip with numerous clients, it could be a slow and painful life fulfilling the requirements of a syndicate contract.

Circulation and length of contract most often dictate the price paid for syndicated material by newspapers, magazines, and even Internet publications. One syndicate, for example, offers weekly columns to their clients under a one-year agreement based on circulation of under 100,000 ($225 a year), under 500,000 ($375 a year), and over 500,000 ($500 a year).

If they land only five clients for your feature, with circulation below 500,000 and another five with less than 100,000, the annual revenue from these sales would be only $3,000. Subtract the standard 50 percent commission of the agency, and you, as creator, have made $1,500 for fifty-two columns. Not too impressive, right?

Now let's consider the up side. The sales staff is extremely aggressive and the topic of your cartoon or column captures the interest of the mass market. You suddenly find yourself syndicated in two hundred newspapers: fifty with circulation of under 100,000, one hundred with circulation below 500,000, and fifty with over 500,000 distribution. The syndicate takes in $73,750 from your work, of which $36,875 is yours.

Keep in mind that these are the figures of one syndicate, based on the rates they charge their clients. One expert in the syndicated cartoon business told me that, in his research, the sale of a feature to one hundred newspapers normally amounts to roughly $40,000 a year for the artist.

From these figures, as you will note in the UPS contract section 7(a)(i) your share of the syndication expenses—mats, proof sheets, camera work, digitalization, reproduction, etc.—must be subtracted. This should not exceed $300 per month or 10 percent of gross collected revenues.

Potential success of a feature is a major consideration in the acceptance/rejection process at every syndicate. It is not a one-person decision, but an overall consensus, including editors, production managers, and marketing personnel. This makes it extremely difficult to break into a major agency, but it also provides some type of insurance—although never a guarantee—that your work will make money, once you've been accepted.

"If your work is accepted for syndication," say the editors at King Features Syndicate, "the proceeds are split 50/50 between the cartoonist [or writer] and the syndicate. Cartoonists [and writers] can make between $20,000 and $1,000,000 a year. It all depends on how many newspapers subscribe to your comic strip [or column] and how many products are made from your characters."

Coming from King Features Syndicate, this is information that can be trusted, as they control approximately 30 percent of today's syndication business. Second place, according to recent figures, is shared by Universal Press Syndicate and United Media (a joint company of United Features Syndicate and Newspaper Enterprise Association), each with about 20 percent of the marketplace. Tribune Media Services holds roughly 14 percent, with Creators Syndicate at

12 percent. The remaining 4 percent falls into other syndicates, including self-syndication operations.

The ". . . how many products are made . . ." phrase in the above quote from King Features refers to licensing and merchandising, two extremely important aspects of any syndicated feature that becomes a "blockbuster." Anytime you see a book, movie, video, T-shirt, mug, or any other product that stems from a syndicated column or cartoon, it is produced through a merchandising or licensing agreement (see appendix C, Contract Analysis, under Section 3: Rights Granted Syndicate). The major syndication agencies have personnel dedicated to such sales, and they often generate as much, if not more, revenue from this area of the business as the actual feature placement in newspapers.

It is the newspaper and magazine sales, however, that generate the exposure needed to drive merchandising and licensing sales. In fact, there is a direct correlation between top syndicated material and spin-off sales. Perhaps no other comic strip illustrates this better than "Peanuts," which has been translated into films, books, videos, advertising, clothing, school supplies, etc. Considering "Peanuts" is the number one–selling strip in the world, seen in 2,600 newspapers, it is no surprise that it has such success—bringing in tens of millions of dollars a year through merchandising sales. The same is true with regard to "Garfield," the second most popular syndicated cartoon, carried by 2,550 newspapers.

Licensing is not limited to cartoonists, however. Many column writers also find spin-off opportunities from the success of their work. Barbara Feldman, author of the column "Surfing the Net with Kids," for instance, had already self-syndicated the piece to fifteen newspapers before Los Angeles Times Syndicate editor Tim Lange contacted her. While signing on with LATS meant losing 50 percent of the income from her existing customers, she realized it offered greater opportunity. Almost immediately, in fact, three publishers contacted her with book deals based on the column.

4

GUIDELINES FOR WRITERS AND CARTOONISTS

Syndication is constantly evolving. For this reason, a top nationally syndicated artist, who preferred I not mention his name, says that newcomers must "study syndication and subscribe to the trade journals, such as *Editor & Publisher.* The world of syndication is very exclusive, and only the most determined artists and writers will make it."

It would be easy for me to provide a list of general topics and say that this is what syndicates are looking for. In all honesty, though, no one really knows—not even the syndicate editors—until they've seen it. In preparing this book, I spoke with hundreds of people in the syndication business. I asked most of them the seemingly unanswerable question: What are you looking for in new cartoons and columns? In nearly every case, the answer was an extremely vague: "Anything new, different, and with mass-market appeal."

Like most syndicate editors, Tim Lange, executive editor at the Los Angeles Times Syndicate, found it easier to explain what he *does not* want to see. In columns, for example, that would include technology, computer, humor, parenting, and Baby Boomer themes.

Similarly, cartoon editors are advising artists to avoid cavemen (*a la* "B.C."), animals ("Garfield," "Mother Goose and Grimm," "Sherman's Lagoon," "Shoe"), children ("Adam," "Calvin & Hobbes," "Peanuts," "The Family Circus"), historical topics ("Hagar the Horrible," "Prince Valiant," "The Wizard of Id") and military topics ("Beetle Bailey"). So, you might ask, what's left?

Honestly, winning over syndication editors requires innovative concepts and the proper approach, rather than general themes. A successful idea will incorporate your creativity, and that is what makes all the difference, and makes it unique. For decades, cartoons like "Archie" and "Spider-Man" controlled the market. Then, an innovative cartoonist with a weird way of looking at the world came onto the scene. Today, Gary Larson's "The Far Side" is one of the most recognized, and loved, cartoons in the world—even if Gary has officially retired. Why? Because Larson took a different view, his approach was unique, and his talent provided a freshness that went beyond the traditional.

Though it may take years to achieve the mental attitude and artistic talent required to successfully place a syndicated column or cartoon, learning the right way to approach an agency can easily be achieved by studying the writers' and cartoonists' guidelines provided by most syndicates.

Major syndicates have Internet Web sites that list submission guidelines—those that do not have Web sites, in today's electronic age, should not be considered as potential distributors for your work. By studying these guidelines, you'll gain insight into the proper format for each agency and, in many cases, learn the likes and dislikes of editors.

To put you on the right track, I've obtained permission to reproduce the guidelines of five syndication agencies. The editors of the following syndicates were more than willing to allow the publication of this information, as it not only helps artists who may be their future clients, but makes their jobs easier when material is submitted in the proper formats. While there are some general similarities, each editor has a somewhat different approach in the way he prefers material and what should be included in a submission package.

American News Service

My apologies to cartoonists for this one, as The American News Service (ANS) distributes "articles only" to newspapers and other media. This is an excellent syndicate for one-shot features, news items, or a series of articles on a single theme. Many writers, in fact, have found that they can make an excellent living through continuous features that fit the needs of ANS and other syndicated news services.

There were two reasons I specifically chose ANS:

1) The fact that they handle only features provides a good look into alternative syndication opportunities—besides columns—for writers

2) Their guidelines illustrate what must go into a feature

Too often writers believe that working with a features syndicate is similar to producing magazine articles. It is not. The list of resources and other information required, as you will find from the following guidelines, can add hours and even days to your workload. On the other hand, the extra effort will insure your articles get serious consideration rather than a quick rejection.

ANS Guidelines

Please review ANS stories on our Web site [see appendix A]. This is the best way to understand how we define an ANS story.

Essential elements: The writing draws the reader in by telling a story that is lively, even gripping, if possible. It conveys the look and feel of the place and characters. The story contains internal tension—conflict, struggle, or contrasting approaches to a problem. They often use one or more examples to suggest broader trends. ANS stories are objective news stories: all points of view expressed are attributed. More specifically, ANS stories have:

1) Significance. They relate to an issue that people really care about. Key elements can include: The story demonstrates a "cutting-edge" development within a problem-addressing trend. The individual, local story is of such novelty that it's inherently interesting, or is part of a trend and may suggest possibilities for addressing similar problems in other communities or on a national scale. Several examples may be synthesized to suggest a national development or significance in regard to a major social problem. The story challenges a prevailing assumption.

2) Relevance to the "search for solutions" to major social problems. Stories may, therefore, be related to, for example: citizen-initiated and guided efforts at problem solving or innovations within major social institutions such as business or government.

3) Vivid detail. Always include some description—even a few words—of the people and places in the story. This is often tricky because of the need to rely on phone interviews. But try, for example, to get a person's age, some physical attribute, or personal background over the phone.

4) Controversy and balance. It is important to include material from someone on the other side or from outside the groups or organizations featured. Because ANS stories are not advocacy pieces, critics' and skeptics' voices must be heard—and in their own words, not as paraphrased by the advocates.

5) Surprise, something out of the ordinary.

6) Clarity, a simple story line that draws the reader through to the end.

7) Timeliness. Relates to concerns that are currently getting some attention nationally.

8) Concrete evidence of constructive effort and outcome, even if there are setbacks and shortcomings. Some lessons, if possible.

9) Enough facts about what actually happened that the reader could do something based on that information. That is, contains more than a vague sense that something positive was attempted.

Check in Before Writing

For in-depth features (800 to 1,200 words): Before writing begins, please call managing editor Peter Seares at 802-254-6167, ext. 125, to discuss the direction the story is taking. Then send a one-paragraph description of the gist of the story—i.e., the budget line—via e-mail to: *pseares@americannews.com*. Please call, or fax to 802-254-1227, if you can't e-mail.

For stories (300 to 750 words) or briefs (150 to 300 words), call the managing editor only if you have questions about the angle or approach to the piece after assignment.

Contact Information

Please supply us with information about all the people you contacted to write your story. We use the contact list at the end in a number of ways.

In fact checking, we call each contact and read them the information that is attributed to them, giving them a chance to correct any errors. For some stories, we create a "Backgrounder" or "Note to the Editor," which is a list of national and regional contacts to help editors localize or deepen a story.

Contacts are also entered into our database for future reference and to help us build relationships with other organizations.

Please inform your contacts that they may receive a phone call from us.

Please get phone numbers; fax numbers; postal, e-mail, and Web site addresses for our records. (Not all this information will go in the actual story, but it is info that we need.) Indicate if a phone number is a home phone—we do not list home phone numbers in the contact list.

Please divide your contact list into people who were quoted in the story or provided you with key facts and background, and people you

may have consulted who do not appear in the story. If you have an extensive list of background organizations or contacts, please include it all and indicate that they are for a "Note to the Editor" or a "Backgrounder," not for story fact checking.

Please submit your contact and background lists in the following format:

Mary Ann Statham, news and pictures coordinator, The American News Service, 289 Fox Farm Road, Brattleboro, VT 05301; Tel. 802-254-6167, ext. 137; fax: 802-254-1227; e-mail: *mas@americannews.com;* Web site: *www.americannews.com.*

Formatting and Sending Your Story

Please put your phone number at the top of the story when filing. To facilitate our editing, please use these formatting guidelines:

1) Use a tab at the beginning of each paragraph.

2) Place two paragraph marks at the end of each paragraph.

3) Format contact lists as indicated above in section on Contacts.

4) Use a single space between sentences.

5) If your word processing program has the option, choose straight quotes instead of "smart" or curly quotes (they appear as something else in e-mail or Web formatting).

Where to File

Please use e-mail, if at all possible. E-mail your copy to ALL OF THE FOLLOWING: *pseares@americannews.com,* *mas@americannews.com,* and *ansedit@sover.net.* If e-mail is not possible, please file by mail with your piece saved onto disk in both of these formats: as a Word for Windows file and as an ASCII (also called "text") file, on a Macintosh-compatible floppy disk.

Please call before mailing so that we can let you know if we need the disk sent by overnight or regular mail.

Administrative Details

Tag line—send us one the first time you file a story with us and any time it needs to be updated.

Contracts—will be sent to you before each in-depth feature deadline; sign and return one copy to us ASAP.

Social Security Number—be sure to include it on your first contract, so we can pay you promptly.

Payment—we pay upon release of your story. To reimburse you for phone expenses, we must receive an invoice and copies of the bills with reimbursable calls highlighted and marked as to which story they

were for. Phone expense invoices must be received by ANS within two months of our release of the story. Any other expenses for which you receive prior approval from ANS should be included in an invoice with accompanying receipts. Please direct all invoices and payment questions to Mary Ann Statham, News and Pictures Coordinator.

Photos and Graphics

Feature story writers: As early into the assignment as possible, please examine the scope for photographs and other artwork. At this point we don't take our own photos, but we are interested in any related pictorial material that your sources may have. Please let Mary Ann Statham, our photo coordinator, know the name and phone number of any sources who have indicated they can send photos or graphics so she can follow up. Contact: Mary Ann Statham, ANS, 802-254-6167, ext. 137.

Photos or graphics can be e-mailed to us directly as JPEG files, sent to: *ansedit@sover.net.*

Material can include regular news-style photos; portraits/head shots, etc.; scenes related to the story; all manner of charts, graphics, and illustrations that an artist may be able to work with as Web site graphics; etc. All material should contain: credit information for the photographer or the organization that provided the photo and full caption details (for multiple photos, sources should number photos and corresponding captions, or write on back of photo if possible).

First class mail will usually do for submissions, but we will let you know if there is more urgency.

Laid-Back West Syndicate

A small, but very active agency based in Perryton, Texas, is Laid-Back West Syndicate. Judy Logsdon, who runs LBW, says, "I've always believed that people who read newspapers do so for reasons other than catching up on the latest news and to see what the specials are down at the corner market. Loyal readers also like to read good stories that make them laugh, cry, and think. Sometimes they even enjoy getting their dander up. They want to be entertained and challenged. Readers want to learn about new things and people, and they also want to see the familiar parts of their lives in a new way."

Logsdon also points out that national syndicates aren't able to offer columns and features with a local flavor. This is why she decided to start Laid-Back West.

"I was already working with John Erickson, and he was turning out a great humor column. I then added Linda Mussehl's column, and suddenly we were off and running as a syndicate."

LBW has been fortunate in representing some of the beloved voices of the southwest, including Jack Macguire's "Talk of Texas" column, currently in its thirty-seventh year, and the world-famous cartoon, "Cowpokes," by Ace Reid.

"I started with one newspaper almost two years ago, and now almost 130 newspapers carry one or more syndicate members," explained Logsdon. "We are pleased with our growth and look forward to continuing that trend."

Anyone interested in being considered for syndication by LBW Syndicate should send twenty-four samples of their writing or cartoon. Prior to doing so, review their Web site *(www.laid-back.com)* to insure your subject and style fit their lineup.

Your samples should include at least three clips from published sources. If you have not been published, your *first* move should be to contact your local newspaper to convince them to publish your work. You might also contact any magazine you enjoy reading to see if they would be interested—you don't have to sell it; sometimes editors are willing to publish free material, which will give you the needed clips.

Submitted material should be of general interest.

When your package is received, it will be reviewed by the owner for content and quality. If it is not rejected at this level, it is passed on to the other members of the syndicate for approval or rejection. This process takes about four months.

All material must be accompanied by a self-addressed, stamped envelope (SASE) if you want it returned to you. Do not send originals. Faxed submissions will not be considered. E-mail inquiries are welcome, but all submissions must come in hard copy via the postal service.

Both cartoon and text submissions should go to: Jody Logsdon, Laid-Back West Syndicate, P.O. Box 712, Perryton, Texas 79070.

Tribune Media Services

Tribune Media Services is a leading provider of information and entertainment products to newspapers and electronic media. TMS syndicates comics, features, and opinion columns; television listings; Internet, online, and wire services; and advertising networks. Headquartered in Chicago, TMS is a subsidiary of Tribune Company.

TMS Guidelines

If you have a newspaper column, cartoon panel, or comic strip to submit, we will need four to six weeks worth of samples to consider. We also would like to know something about the author or artist; a simple resume will do.

If your work has been published elsewhere, that is a good recommendation, and we would like to know about that, too.

We suggest that you send us 8½" × 11" copies of your material, not the originals, as we do not guarantee return of materials. If the work being submitted is a comic strip, we would like to have a short note about the characters in the strip, explaining how they relate to one another.

We will evaluate your work in terms of current newspaper requirements. Please allow several weeks for a reply (at least six to eight weeks). If you wish to have your samples returned to you, please enclose a large stamped, self-addressed envelope (insure there is sufficient postage). If you do not include this or you provide insufficient postage, we will not return your material. NOTE: Please do not meter the SASE. The Post Office now requires that metered mail be stamped with the same date of mailing. The Post Office may not deliver your return package, or may deliver it "postage due."

Send your submission to: Tribune Media Services, 435 N. Michigan Avenue, Suite 1400, Chicago, IL 60611, to the attention of either: Fred Schecker, Creative Director, News & Features; Tracy Clark, Submissions Editor; or Franceska M. Clark, Editorial/Licensing Assistant.

United Feature Syndicate and Newspaper Enterprise Association

One of the nation's largest syndicates, United Feature Syndicate and Newspaper Enterprise Association is located in New York City and handles a full range of editorial materials, from box comics and strips to fillers, columns, and full-length features. They offer separate guidelines for writers and artists on their Web site *(www.unitedmedia.com)*.

UFS/NEA Guidelines for Cartoonists

We are looking for innovative comic features with interesting characters and ideas.

Most cartoonists use ink or brush and speedball pen for lettering. Work in whatever size you find comfortable, but remember to keep your work in the right proportion for reducing to newspaper size. Your artwork should be clean enough to reduce to newspaper size.

We would like to see three weeks (eighteen dailies) of samples so that we can judge the consistency of your work. Color Sundays are not necessary with your first submission.

Please include a short cover letter about yourself and your creation. Lengthy character descriptions, licensing prototypes, and large presentations are unnecessary and make our job more difficult. Submit photocopies or photostats on sheets no larger than 8½″ × 14″. Never send original art.

Your full name and address should appear on both your envelope and on the back of each piece of art you submit. This makes it easier to keep track of your material. Parts of submissions often become separated from each other.

Include a self-addressed, stamped envelope large enough for the return of your material. Submissions not accompanied by SASE will not be returned. If you are overseas, please enclose international postal coupons. Send your submissions to:

Comic Editor
United Feature Syndicate/Newspaper Enterprise Association
200 Madison Avenue, 4th Floor
New York, NY 10016

Our response time is usually 8–12 weeks.

We regret that we cannot grant appointments prior to seeing your work.

In order to speed up the process: Please do not send additional material until you receive a response. If we are interested, we will ask you to submit more, including originals. Please do not send oversize material or material that requires special handling.

Answers to Commonly Asked Questions

1) Q: Which are more in demand, strips or panels?
 A: Truthfully, it really doesn't matter. If the idea you've developed lends itself to panel format, draw it that way; if strip, then draw it that way.
2) Q: How much do you pay cartoonists?
 A: We pay our cartoonists the standard syndication royalty split.
3) Q: I've written a comic strip, but I'm not an artist. Can I still send it to you?

A: Please find yourself an artist interested in both cartooning and your idea. Have him/her draw the strip, then send us your submission. A number of strips are written by one person, drawn by another. We do not find artists for writers or vice versa.

4) Q: Should I copyright my strip before I submit it?

A: We advise you to consult a lawyer if you are concerned about copyright ownership. You might also check your local library for books that address this issue.

5) Q: How does syndication work?

A: Syndicates promote, sell, edit, and send features (comics, columns, puzzles) to newspapers. We also represent our features in a variety of worldwide subsidiary venues, such as licensing, publishing, and electronic media.

United Media is comprised of two syndicates, United Features Syndicate and Newspaper Enterprise Association. Although the two syndicates differ in the way they market material to newspapers, the features are handled by the same editors, sold by the same sales force, and licensed by the same licensing executives. Your contract would be with the individual syndicate, and you would be well advised to the differences between the two syndicates before you were asked to sign any contract.

6) Q: How many comic submissions do you get, and how many do you accept for syndication?

A: We receive more than four thousand submissions a year. There's no set number of acceptances, but we average two or three new comics a year.

UFS/NEA Guidelines for Writers

Column proposals should be targeted toward a minimum of weekly frequency. We do not buy one-shot articles or series articles. If you are proposing a column, we would like to see four to six samples—no more than that in the first submission.

Preference is given to established writers and to those who already have a client list through self-syndication.

Submissions should be typed, double-spaced on white bond paper. If your material is already published, tearsheets are acceptable. Column length, as a rule, should run between 500 and 700 words.

Our syndication agreement calls for an equal split of net cash proceeds from sales of a feature.

If we are interested in a feature for one of our "package" services, we will negotiate a per column payment.

If you desire a reply, your material must be accompanied by a self-addressed, stamped envelope. If return of submitted materials is required, include a SASE large enough and with sufficient postage to cover the cost.

Please send submissions to:

Robert J. Levy

Executive Editor, UFS/NEA

200 Madison Avenue, 4th Floor

New York, NY 10016

Universal Press Syndicate

Universal Press Syndicate is among the cream of the crop when it comes to syndicates, distributing many of today's top writers and cartoonists. This, however, is not the reason I've chosen to include their guidelines herein. Within their listing, they answer many commonly asked questions that may be helpful as you explore the submission of your work.

Like other syndicates, UPS receives mailbags each week that are filled with submissions. Following their guidelines will insure a faster response and take you one step closer to acceptance.

UPS Guidelines for Writers

Length requirements: Many papers today are tight for space, so we generally look for text features that are between 650 and 800 words.

How many columns should you submit? We prefer to see six to ten samples of your proposed feature so that we can judge the quality and consistency of your work. Please submit copies only, and make sure the material is clear and easy to read. Only one copy of each column need be submitted.

What compensation is paid for syndicated text features? It is impossible to quote specific rates paid for any feature. Rates depend on the popularity of the feature and the number and circulation of the newspapers that carry that particular feature. Generally, our contracts provide for an equal division of revenue with the creator, after deduction of production costs.

What should be included with the feature you submit? Please include a letter explaining the purpose and scope of your material. A stamped, self-addressed envelope for the return of the material must

be enclosed. We will not return material that is not accompanied by a SASE. Be sure your return address is on both the letter you send and the submitted material.

To whom should your feature be sent? Sent it to Mr. Lee Salem, Editorial Director, Universal Press Syndicate, 4520 Main Street, Suite 700, Kansas City, MO 64111. While we make every effort to review your material as promptly as possible, it generally will take four to six weeks for you to hear from us.

UPS Guidelines for Cartoonists

Universal Press Syndicate is always looking for great new comic strips. Your work will be reviewed by Universal editors, and each month, the work of one new creator will be selected for review by visitors to Uexpress (the company Internet Web site) as well. After their month in the limelight, highlighted strips will be included in the StripSearch archive.

Let us know if you'd rather we didn't hold up your creation to the scrutiny of the Web. But we hope you won't be faint of heart!

How many cartoons should you submit? We prefer four to six weeks of samples. As long as the material is clear and easy to read, it may be submitted in any form. You may e-mail a URL for our editors to visit online, or you may send copies or stats by snail mail. Do not send originals. Please keep your submissions compact.

What should be included with the comic strips/panels you submit? Please include a letter or e-mail explaining the purpose and scope of your material. Include a SASE.

What size should you draw your comics? Usually, comic strips and panels are drawn twice the size that appears in your local newspaper. Any size is acceptable as long as it can be reduced proportionately. Strips should be reduced to 10 × 38.4 picas; panels to 24 × 19 picas.

What materials do cartoonists use? Some cartoonists use a quality Bristol board and black India ink. Others use marker pens on chemically treated paper for their cartoons; but a consistent, quality black-line drawing is necessary. Zipatone (or other shading sheets) is sometimes used for shading, although many cartoonists use freehand line shading. (Note that any shading tone used must be no finer than sixty-five–line screen in the reduced size of the cartoon.)

How far ahead of deadline do cartoonists work? Usually, cartoonists work four weeks ahead of the release date for daily releases and eight weeks ahead of release date for Sunday releases.

What compensation is paid for syndicated comic art features? It is impossible to quote a specific rate, [because it] depends on the newspapers that carry that particular feature. Generally, our contracts provide for an equal division of revenue with the creator, after deduction of production costs.

To whom should you send your features? For hardcopy submissions: Mr. Lee Salem, Editorial Director, United Features Syndicate, 4520 Main Street, Suite 700, Kansas City, MO 64111. For electronic submissions: E-mail the URL for the Web site where your work is displayed to *stripsearch@uexpress.com.* Please do not send your comics as attachments to your e-mail.

COLUMN SYNDICATION: TIPS FROM THE PROS

Some people wish to be syndicated columnists for the money, others for the power. Yes, there is power in daily, weekly, or monthly columns that reach thousands, sometimes millions, of readers across the country. One example of this "power" can be seen in the book publishing industry.

Publishers large and small go to great lengths to wine and dine nationally syndicated writers. Why? Because, as a recent issue of *Book Marketing & Publicity* pointed out, "There's nothing like having a syndicated columnist refer to, quote from, or review your book. . . . Recently, advice columnist Ann Landers mentioned *Smart Love* by Martha Heineman Pieper. Within a day, the book had jumped to number 40 on the Amazon.com top 100 list, and Harvard Press is printing up 40,000 more copies."

This is merely one small example of how a successfully syndicated writer can influence the general public. So, if you think that syndication can change your life, you are probably right. Problem is, the same people that provide you the avenue to success, fame, and financial reward are also offering you a one-way ticket on a fast train that could end up in a blind tunnel. It's like the room with three doors. Behind one are fame and fortune (we'll leave out the beautiful woman or man); behind the others are lions, waiting to eat you alive.

A veteran columnist, who preferred not to be mentioned for fear his syndication company would read this book, said that "The glamour disappears quickly in this business. Writers must always keep in

mind, even if picked up by the finest syndicate available, that they are in it for the money—there is no loyalty or friendships. If you approach it as a business, and always keep it in that content, you can come out a winner. No one is doing you any favors. It's hard work, day in and day out."

To keep you from opening the doors that hide the lions, I contacted several syndicated writers, who were not so fearful of giving their identity, and asked if they could provide suggestions to those wishing to join the ranks of syndicated columnists. Their remarks can be found in the question/answer sessions that follow.

I have also included a couple of successful self-syndicated writers in this list, as this is an area of the business that most artists must consider, particularly at the onset of their career. For some, the challenge and reward of self-syndication is far more enjoyable than column writing alone. One of the top nationally syndicated writers in America told me, in fact, that "If I were to do it all over again, I'd self-syndicate and reap all the benefits."

Azriela Jaffe, "Advice from A to Z"

Jaffe began the "Advice from A to Z" column in 1996. Today, it is read by approximately one million people in such publications as the *Los Angeles Times* and *Business Week Online*.

Q: *How did you break into national syndication?*
A: I wrote my column for a small newspaper in Oregon until I had collected enough samples to approach larger newspapers. Then I worked hard to get it accepted in my local hometown, Lancaster, Pennsylvania. After I had run there for a year and had quite a selection of samples, I started self-syndicating nationally.

Q: *What advice would you give to writers wishing to become syndicated?*
A: It takes enormous patience, persistence, and courage, and you will spend an enormous amount of time on the phone getting rejected. But if you want it badly enough, you must be willing to do the work. Also, buy my book, *Starting from No: Ten Strategies to Overcome Your Fear of Rejection and Succeed in Business,* which will give you plenty of strategies for handling the rejection that comes with syndicate sales.

Q: *What are, in your view, the pros and cons of national syndication?*
A: Pro—you don't have to spend your time doing sales calls and col-

lections. Con—they keep a significant portion of your fee, and sometimes don't do much to market you.

Q: *How important is it to know the marketplace?*
A: Know what part of the newspaper you belong in and who your ideal target market is—that's most important.

Q: *How do you submit your work?*
A: I submit all of my work by e-mail.

Q: *Where should a writer start?*
A: Get yourself anchored somewhere for at least six months to a year before ever attempting to expand. Make sure your column is unique.

Pippa Wysong, "Ask Pippa"

Pippa Wysong is a Canada-based writer and author of the question-and-answer science column for kids, "Ask Pippa," distributed by The Toronto Star Syndicate. This is an excellent example of a writer finding a niche and filling it.

Q: *What is your background?*
A: I have had a freelance science column on the children's page of the *Toronto Star* since 1989. . . . While I have been listed (in *Editor & Publisher Directory of Syndicated Services*) as a self-syndicate for a number of years, I did not actually become syndicated until 1998.

 Several years ago, I phoned up the offices of *Editor & Publisher* in New York City, a directory of syndicated columnists, and found that to be listed was free. The only requirement was that you must have an established column—and you need to submit proof you have a regularly appearing column. I did have an established column and signed up. Over the years I have had several nibbles from small U.S. newspapers.

Q: *What do you tell writers wishing to break into syndication?*
A: Prove you can write and meet deadlines. You need to have an established column first in a newspaper or magazine before you can ever think about syndicating. After all, how can you market a proven product if you don't have one?

 I ended up with my "Ask Pippa" column after one out-of-the-blue visit to the children's editor of the *Toronto Star.* Okay, I

phoned first, introduced myself, and made an appointment to meet her. I had writing samples in hand. The next day, I was told I had a column. It was my first cold call.

After you do your research, approach local editors with sample columns. Try to get feedback. Listen to the feedback—even if you don't like it. You'll learn something.

Q: *What are the good and bad points of syndication?*
A: The pros are the additional payments—which, by the way, are quite small amounts from each outlet. The cons are the time and organization it takes to get pieces in. You do not want to hand anything in late, ever.

Q: *What about your readers? Your target market?*
A: You need to know not only the marketplace, you need to know your target audience. Read the outlets you are considering syndicating to. What is their writing style? Who is their audience? Where does your column fit into their format?

Q: *What equipment should a writer have for syndicated work?*
A: Up-to-date computer equipment with good telecommunications, including e-mail capability, fax, and an Internet browser. Some [syndicates] will want copy in HTML format or JPEG files if your column has a specific look to it.

Know exactly which format each outlet wants. For those syndicating print stories, the format can vary widely. Some customers will want faxes, others will want unformatted text e-mailed to them, while others might insist on an e-mail attachment in a specific word processing format. Some may require some sort of key codes embedded in the text.

Q: *Any advice for newcomers?*
A: Don't expect anything unless you already have a column and a good setup to send your copy off quickly and efficiently.

Amy Alkon, "Ask the Advice Goddess"

Humor and good writing seem to make up a winning formula for successful syndicated columns. Amy Alkon, creator of "Ask the Advice Goddess," possesses both of these qualities. Her column is featured in newspapers throughout the United States and Canada. Amy's wit provides the foundation for answering the hundreds of letters she receives and uses in her work.

Q: *How did you get your foot into the syndication door?*
A: I groveled. I also wore a lot of tight, black clothing.

Q: *If someone wanted to get into syndication, what would you tell him?*
A: Pick lettuce; you'll make more money.

Q: *What are your views of the pros and cons of national syndication?*
A: This is both a pro and a con: I enjoy letters from convicts across the United States and Canada who swear that they are in maximum security institutions for offenses like driving on an expired license. Of course, they neglect to mention that they were bludgeoning the person next to them while doing it.

Q: *How do you submit your work to the large, national syndicates?*
A: Show up naked to their offices—if you have a good body. Otherwise, offer to buy them a new Lexus, and maybe they'll take your work.

Q: *What is your advice on self-syndication?*
A: More lucrative than picking pears. Less lucrative than picking lettuce.

Q: *Are there any Web sites you'd recommend writers to review for syndication advice?*
A: I think United Features Syndicate has one that's pretty good. Either them or Universal Press Syndicate. All those U's so early in the morning; they're killing me!

Tom Philpott, "Military Update"

Find something you know and turn it into something others want. That is the key to Tom Philpott's successfully self-syndicated column, "Military Update," which goes to newspapers and magazines across the nation. While most writers might have thought this topic had a limited market, Tom realized from the onset that there was a niche to be filled, and he filled it.

Q: *What is it about your background that makes "Military Update" your perfect niche?*
A: To produce it, I draw on more than twenty years of experience covering issues U.S. military people stationed around the world care about. To syndicate it, I convinced one editor at a time that this was a news column that a large segment of their readership cares about.

Q: *How might other writers break into syndication?*

A: Don't even attempt it unless you are personally confident you can produce a column readers will care about. If you aren't sold on it, you will be unable to persuade editors—always tight on space—that they should care about it. But if you believe you've got something special, don't be discouraged by the first or second rejection. Keep producing columns or samples of columns you're proud of.

Q: *What are the pros and cons of syndication?*

A: One con would be you cannot influence what a particular newspaper might do with your column. Some attach strange headlines. Some, from time to time, will drop a byline. Some will cut it to fit a news hole in a rather arbitrary way. A definite plus is the number of readers you can reach. It's a lot easier to get an interview with the secretary of defense if your column appears in fifty newspapers than if it appears in one newspaper, or two with a total circulation of 50,000 or 100,000.

Q: *How important is knowledge of the marketplace and readership?*

A: Extremely important. Editors have many options to fill space. A successful columnist finds a need and fills it better than anyone else could. But you have to have a pretty good idea of what your readers want and need.

Q: *How do you submit your work?*

A: I distribute to newspapers myself using e-mail with computer modem or, in some cases, a fax machine.

Q: *Any tips for newcomers to the self-syndication business?*

A: It's tough getting started, but it's wonderful being your own boss and keeping whatever income you generate.

6

CARTOON SYNDICATION: TIPS FROM THE PROS

No one is better prepared to offer would-be cartoonists advice and insight than someone already working in the field of national syndication. For this reason, I asked several active cartoonists a series of questions, in hopes that they could shed some light on the real ins and outs of this seemingly glorious business. Most of them agreed that the glamour is just an illusion and that syndication is tough work.

Of those cartoonists that replied to my queries, I've selected three for this chapter: Steve Moore, Jeff Miller, and Bill Holbrook. These talented artists, in their questions and answers, provide an overview of the good, the bad, the ugly, and as one creator pointed out, the damned lucky.

Steve Moore, "In the Bleachers"

A California native, Steve Moore set out to be a newspaperman—making it all the way to executive news editor at the *Los Angeles Times*. A twist of fate, however, led to his developing the popular sports cartoon, "In the Bleachers," syndicated by Universal Press Syndicate.

I first contacted Steve long before this book was conceived, because I found his work to be unique as well as entertaining. The question-and-answer session of our communications follow:

Q: *How does one go from a major newspaper editor to a syndicated cartoonist?*

A: I'm no longer executive news editor for the *Los Angeles Times.* "Bleachers" grew to a point where it was in need of more attention, and the income grew to a point where I could afford to quit the "day job," so I quit in March [of 1996] to concentrate on "Bleachers" and to launch a career in animation. I hated leaving journalism, especially after having invested ten years at the *Times* and another six years of schooling (bachelors and masters degrees).

Q: *How did you get into Universal Press Syndicate?*

A: I ended up at Universal Press Syndicate after having started syndication with Tribune Media Services. In 1995, the contract with TMS was up, so I became sort of a cartoonist version of a "free agent." I had always wanted to be with Universal, because they have serviced all the legendary cartoons like "Doonesbury," "Calvin & Hobbes," and "The Far Side," so I made the leap.

Q: *How did you come up with your "Bleachers" concept?*

A: I created "Bleachers" to break up the gray type on the sports "facts and figures" page. I was a sports editor for a newspaper in Hawaii, the *Maui News,* [at the time] and wanted to add a cartoon to the scores page, but couldn't find one in syndication that fried my burger. "Tank McNamara" was available, but it is mostly topical satire. I wanted something purely escapist. Something to create a diversion from the day-to-day reportage of sports. At the same time, I wanted a cartoon that would grab the sixteen-to-forty-year-old readers. They are the group most likely to wander away from newspapers and into other media. I felt it would be valuable to a sports editor in this highly competitive media age.

Q: *You have a very unique style. What do you contribute this to?*

A: I had discovered the world of cartoonist B. Kliban, [when] a friend lent me two of his books: *Whack Your Porcupine* and *Never Eat Anything Bigger Than Your Head.* Very strange stuff. I couldn't believe I had found another human being with the same weird imagination as myself. That's when I became serious about cartooning. Then Gary Larson's "The Far Side" came along [Larson was also influenced by B. Kliban] and broke down all the barriers to that kind of humor in newspaper syndication. At that point, I decided just to do my own damn cartoon for the sports page [in the *Maui News*].

Q: *What was your approach to the syndication industry?*

A: I took two weeks' vacation from the *Maui News* in 1995, sat on the beach, and pounded out about fourteen samples of my "In the Bleachers" concept. Then I made Xerox copies and sent them off to three syndicates. The Los Angeles Times Syndicate originally wanted the cartoon, but then their editor resigned. During the delay in finding a new syndicate editor, Tribune Media Services called and offered me a contract. That same month, and unrelated to the cartoon, I applied for a job at the *Los Angeles Times.* They flew me to L.A. for an interview, and three weeks later, I was working in the *Times'* sports section. I had a pretty decent month.

Q: *How did you focus your cartoons?*

A: I did "Bleachers" as a sports cartoon for two reasons. One, I didn't want to jump into the huge "The Far Side" clone feeding frenzy that was going on. I carved my own little niche that would not overlap into the land of Gary Larson. Second, I have been involved in sports all my life and into my career as a journalist, so I figured I had a fairly vast reservoir of experience to draw from. The one rejection I got when I submitted "Bleachers" to syndication came from the *Washington Post* Writers Group. The editor there wrote back and said, "I hate like hell to turn you down," but he said it would be too difficult to sell a sports-related panel. I don't think he recognized the huge growth in the sports world that has been going on since the eighties.

Q: *What, in addition to your syndicated work, are you up to?*

A: I am currently working in animation on the side. I have worked in development and written animation scripts for a new Warner Brothers children's cartoon that debuted in 1998. I wrote for Universal Studio's *Casper* cartoon series. As for "Bleachers," as I write this, I am negotiating with Viacom/Paramount for an "In the Bleachers" TV project.

Q: *What about print media?*

A: "Bleachers" has been published by MacMillan in four collections. Two are still in circulation and can be ordered: *Where Golfers Buy Their Pants* (all golf cartoons) and *Back to the Bleachers* (all baseball).

Q: *What is the reality of becoming a nationally syndicated cartoonist, in your view?*

A: The reality of making a living at syndicated cartooning is that it is nearly impossible to break into and, once you get syndicated,

you have to keep your day job unless your feature manages to attract 150 or more clients. The huge successes, such as "Peanuts" and "Dilbert," haven't a worry in the world. They are rolling in bucks. The majority of syndicated cartoonists, however, still need to watch their credit card balances. I'm at a transitional stage right now. Just moving out of the "economy class" and into God-knows-what. "Bleachers" seems to be on that magical cusp. "Dilbert" was like that a few years back. Sort of on the verge of growth, then—boing!—it took off.

Q: *What advice would you give to those interested in becoming cartoonists?*

A: Advice for future cartoonists? Go to college and plan on some other career. Keep drawing on the side. Try to get published in any way you can. Find a mentor—a cartoonist who matches your sense of humor and learn from him or her, study their work as any other artist would study one of the great masters. Then slowly—in my case it's been excruciatingly slow—develop your own style. It's the same evolution as in any other art form.

The reality is that only a hundred or so people in the world make a good living at syndicated cartooning. Your chances of breaking into the NBA are probably better. That's why I would recommend having a career to fall back on. I really, really lucked out, and I never forget that. I know there are thousands of people in the world who would love to be in my shoes.

Q: *Some cartoonists find their syndicated work literally "takes over" their life. How do you deal with this?*

A: I never have trouble stepping out of the cartooning mode. That is a direct result of having worked for ten years as both journalist and cartoonist. It was pure survival. I had to be able to leave Times Mirror Square in downtown L.A., fight through rush-hour traffic, and churn out cartoons when I got home. For a while, to help the transition, I was getting off work at 8:00 or 9:00 at night, then on the way home stopping off at The Improv, a stand-up comedy nightclub in Hollywood. I'd buy a ticket and grab a table by myself and just soak up the humor to get me in the mood to do my cartoon. It helped drain my noggin of all the drive-by shootings, earthquakes, and other mayhem that we dealt with daily at the newspaper.

Q: *How do you coordinate family and cartooning?*

A: My wife thinks that the cartoon career is a blast, although she

often will look at one of my drawings, wrinkle her nose as if some-one just farted and say, "I don't get it."

Q: *How do you deal with the "fame" of being a cartoonist?*
A: I'm sort of embarrassed of the whole thing. I have a hard time say-ing, "I'm a cartoonist." It sounds so silly, like "I'm a professional surfer" or something. I'd rather say that I'm a doctor or a journal-ist or an undertaker. "I'm a cartoonist" sounds as if I should be dig-ging a finger in my nose or scratching my butt when I say it.

Q: *I know you have a son. How does he perceive your career?*
A: My son doesn't fully comprehend my cartoon job. He loves watch-ing cartoons on TV and looking at the comics page in the news-paper, but he hasn't figured out yet that his old man is one of those morons who create cartoons.

Jeff Miller, Co-creator of "Tank McNamara"

One of the busiest cartoonists in the business, Jeff Miller is one-half of the creation team responsible for "Tank McNamara," distributed by Universal Press Syndicate. I was fortunate in that Jeff took time out of his schedule to provide some brief insight into the strip and syndication in general.

Q: *How did you break into syndication?*
A: My partner, Bill Hinds, and I sent samples of "Tank McNamara" to Universal Press Syndicate. They asked us for more samples. Then they offered us a contract.

Q: *What advice would you give to cartoonists wishing to become syndicated?*
A: Newspapers have no need of a second "Doonesbury," "Garfield," "Cathy," or "Dilbert." These strips already exist. You'll have better luck listening for your own unique voice than trying to imitate others.

Q: *What are, in your view, the pros and cons of national syndication?*
A: The pro of national syndication is that you have a chance of mak-ing a lot of money. There are no cons of which I'm aware.

Q: *How important is it to know the marketplace?*
A: Vital. We started "Tank" because there was nothing out there about sports at the time.

Q: *How should one submit their work?*

A: Image-on-paper—at least six weeks' of dailies—is probably best. Universal Press Syndicate offers submission directions on their Web site.

Q: *What is your advice on self-syndication?*

A: It's very difficult. Few newspapers will consider self-syndicated work.

Q: *Are there any Web sites you'd recommend cartoonists to review for syndication advice?*

A: Reubens.org (the Web site of the National Cartoonists Society).

Bill Holbrook, "On the Fastrack"

Humorous misadventures in the contemporary workplace and the personalities behind Fastrack, Inc., is the theme of "On the Fastrack," the successful strip by artist Bill Holbrook. Now read in nearly a hundred newspapers across the country, "On the Fastrack" has been distributed by King Features Syndicate since 1984.

In 1988, Bill also introduced "Safe Havens," which looked at the interaction between children and the adult world. According to King Features, this strip is now sold to over fifty newspapers.

Holbrook did not "fall into" cartooning. It has been part of his personality since childhood. In school, he recalls, he would ". . . draw a cartoon based on what the teacher was saying, and it would go around the class until the teacher confiscated it. It would get laughs from the class, and laughs from the teacher, too."

A graduate of Auburn University, Alabama, Holbrook worked as an editorial staff artist at the *Journal and Constitution* in Atlanta. During a trip to the West Coast in 1982, Bill met the creator of "Peanuts," Charles Schulz. The advice of this cartooning legend changed Holbrook's way of looking at the business.

Q: *What did Schulz tell you that you can pass along?*

A: When I was twenty-three, Charles Schulz gave me the following advice: sit down and draw fifty strips. Of those, maybe five will be funny. Build on those and throw out the rest. Do fifty more. Now perhaps ten will be usable. Repeat this process again and again.

Q: *When did you first begin to consider cartoon syndication?*

A: I was submitting strips during my college career at Auburn and later, after I began work at the *Atlanta Constitution*. In 1983 I

developed "On the Fastrack," and it was picked up by King Features. It debuted on March 19, 1984.

Q: *What are the benefits of syndication?*
A: Once a strip is launched, the syndicate's sales staff sells it to newspapers, which is a difficult proposition with fewer and fewer papers operating.

Q: *What are the drawbacks?*
A: They take a 50 percent cut of the income.

Q: *What are the mechanical materials used in drawing your cartoons?*
A: I put tracing vellum over my pencil sketches and ink with a #0 Rapidograph pen and an Osmoroid cartridge pen.

Q: *How should cartoonists approach syndicates?*
A: A submission usually consists of at least thirty strips, twelve of which could be in finished form—the rest can be pencil roughs. There could be a brief cover letter introducing the premise, and after that, the strips should speak for themselves. My strips are affiliated with King Features, where proposals can be sent to this address: Jay Kennedy, Comics Editor, King Features Syndicate, 235 East 45th Street, New York, NY 10017.

Q: *If you could do it over again, what would you change?*
A: Not a lot. I have few regrets.

part II

SELF-SYNDICATION

THE SELF-SYNDICATION ROUTE

"I have received thousands of queries from artists who hoped to be the next Erma Bombeck, Dave Barry, or Gary Larson," explains Angela Adair-Hoy, president of Deep South Syndication. "While I am certain that there are more Ermas, Daves, and Garys out there, they haven't yet come across my desk. That's not to say that the thousands of writers and cartoonists seeking to break into national syndication do not have talent, nor that their work does not merit national attention. It simply means that directly approaching major syndicates may not be the right path for them at this particular time. For these people, I would suggest self-syndication."

When talking with colleagues, I often mention self-syndication, to which I normally receive one of two responses: 1) Are you saying I'm not good enough to get picked up by an established syndicate? 2) That sounds like a lot of work, and I have no idea where to begin.

The answer to number one is no, this definitely does not mean that you are not talented enough to be offered a contract from the likes of Universal Press Syndicate. As I pointed out in chapter 1, however, such agencies are overwhelmed with material, day in and day out. It's like a man dying of thirst suddenly being plunged into the middle of a fresh water lake—there is just too much of a good thing. With smart self-syndication, you narrow the playing field and make your own decision whether to market your work locally, regionally, nationally, or internationally.

And what about number two? Well, yes, it is a lot of work. Where you should begin is marketing.

"Artists have a tendency to avoid the business aspects of the industry, which is based on sales," explained Woody Wilson, writer for such comic strips as "Rex Morgan, M.D." and "Judge Parker." "Selling is all a syndicate does. . . . A creator must [also] know the marketplace and what is going on within the newspaper industry."

Self-syndication is basically the marketing of one's own work—columns, features, cartoons—to newspapers and/or magazines. I've been conducting such activities for the past twenty-one years. Selling, as you will learn in the pages that follow, is just one aspect of marketing. As a self-syndicated artist, you will be tasked with not only the creative side of your feature, but also the business aspects: establishing yourself as a company, maintaining the necessary equipment, knowing the proper formats in which to present your material, setting payment rates, invoicing, and promoting yourself as well as your work. The benefits of this extra effort—complete control, taking in 100 percent of the profits rather than 50 percent, knowing the clients personally—are often justified in the end.

There are many nationally syndicated writers and cartoonists that, looking back, realize that they might have been better off going it alone, because of the control and ownership self-syndication offers.

"A number of syndicates wanted to syndicate 'Spider-Man,'" recalls Stan Lee, "but I didn't want to do it until I could figure out how to present Spidey in only two or three panels a day without losing the flavor I felt he needed. When I finally thought I had figured it out, we simply gave it to the syndicate that we felt had the best understanding of how 'Spider-Man' should be handled. At that time, in 1977, it was the Register & Tribune Syndicate. If I were starting out now, I would want complete ownership of whatever I created."

Syndication is definitely a lot of work, but it can also be fun and rewarding. If you're a control freak, like myself, it offers peace of mind, because you constantly know the status of everything you do.

How to begin in self-syndication is what part 2 of this book is all about. It will guide you through the complete process, from part-time cartoonist or writer to nationwide syndication. The market is material heavy, and it can often be discouraging. But if you have the talent, the desire, and the drive, you can become a famous syndicated cartoonist or columnist—just like Erma, Dave, and Gary.

Going It Alone

James Dulley, the self-syndicating wizard of "Sensible Home," is a perfect example of what talent, hard work, and marketing savvy can

achieve. From a single newspaper, his column has expanded, through self-syndication, to over four hundred newspapers and thirty magazines. The results? Over $1 million a year. And therein lies another advantage of self-syndication: profits.

Had Dulley chosen traditional syndication, he would have given up probably 50 percent of that annual income to the agency, not to mention a portion of the profits from books, videos, and any other potential merchandising licenses.

The following pages will take you through the simple steps to self-syndication. This text contains no fluff. We begin with the tools you need and move on to column and cartoon creation, marketing and sales, and future opportunities that may arise from your syndicated work. Don't expect a rose garden, because you won't find it. Do expect satisfaction and gratification for your labor and determination— which only this type of work can provide. It may take time, but ultimately, you, too, can reap the rewards of self-syndication.

If you've got what it takes to succeed—for example, talent and bull-headed determination—you may find, as some individuals have in the past, that you enjoy the business aspects of syndication as much as the creative side. You may end up offering your company name and marketing skills to other artists and, ultimately, become a giant in the world of syndication.

You don't think so? Well take Richard S. Newcombe as an example. In 1986, Newcombe decided to begin a syndication agency. One year later, the day after Christmas to be exact, his firm was on the edge of bankruptcy. To make things worse, the company's entire computer system had been stolen on Christmas day. No one would have condemned Newcombe for giving up at that point—I know I certainly wouldn't have. But the unique, self-determined philosophy of this businessman kicked it. Utilizing equipment that was borrowed or used, he continued to produce, package, and sell syndicated work. More than that, the natural salesman was driven by his poor luck to knock on doors, night and day, visit editors, and push harder than ever before.

"Problems," he explains, "are really disguised opportunities. . . . I had unshakable faith. . . . I'd crawl over broken glass, I'd live in a tent—it was going to happen."

And happen it did. Today Creators Syndicate, the company Richard Newcombe founded, is a multimillion-dollar corporation, handling such columnists as Robert S. Novak, Hillary Rodham Clinton, and Molly Ivins. Its stable of Pulitzer prize–winning editorial cartoonists includes Doug Marlette and Mike Luckovich. And

let's not forget Ann Landers and "B.C." creator Johnny Hart who, with fellow cartoonist Brant Parker, also does "The Wizard of Id."

"I think when you have the kind of steely determination [that I had]—sort of like Margaret Thatcher or Winston Churchill—people get out of the way," explained Newcombe.

Creators Syndicate is one of only two independent agencies founded since the 1930s and the first successful independent syndicate in two decades. Yours could be the third.

Tools of the Trade

Like any business, there are certain set-up costs for self-syndication. Your largest expense, without a doubt, will be equipment. Fortunately, office equipment is a legitimate tax write-off, though the purchase price must be spread out over a number of years—so save all receipts.

You probably already possess some of the necessary tools to establish a syndication agency. These include: computer and laser printer, or word processing service, scanner, fax machine, e-mail account, letterhead and business cards, a good supply of postage stamps, and a professionally produced photograph. Of course, cartoonists will need the necessary tools of their trade—pens, black ink, paper, dot-transfer, etc.

A computer with a quality word processing program is essential. If you do not own a computer, I recommend you purchase one immediately and learn the basic skills required for daily office functions, as well as Internet navigation and e-mail.

A laser printer is also a must. My first laser was a monstrous Hewlett Packard costing $3,500. Today, tiny desktop models are three hundred times more efficient and sell for less than one-tenth of the "early-days" price. You may need camera-ready columns or scanned strips in the future. Laser printers are capable of producing these in high quality.

A good scanner is a must for cartoonists. While photocopies of your work will sometimes suffice, if you plan to submit your work electronically, or in high quality, multiple copies, you must be capable of taking it from the drawing board to digital format.

A fax machine saves time and boosts your professional image. Editors may request that your columns be sent by fax, or may make last-minute changes to your features and need to fax them to you for approval. In addition, a fax number listed on your letterhead improves your image as a professional. You have three choices with regard to faxes: buy a machine (around $200 at your office supply

store); have faxes sent through your local copy shop or office supply store (where you will pay a small fee to send and receive); purchase a computer-based fax modem to send such transmissions electronically. In the latter case, if you are a cartoonist, you will need to have a scanner linked to your computer as well (to get the graphics into digital format for faxing).

E-mail is the communications medium of the future—as well as today. Most editors will request that you submit your columns by e-mail or on disk, thus saving them typing time. Cartoonists may also be required to submit digital strips or boxes. You should accept this mode of business with open arms, as it will save postage, make multiple submissions as easy as pushing a button, and with electronic submissions, you will frequently receive immediate responses. E-mail also serves as a wonderful marketing medium.

At the same time you are gearing up for business in the twenty-first century, stationery and business cards are still a necessity. They not only improve your image as a professional creator, but allow you a means to "get in front" of potential buyers with everything you send, or during personal visits to editors, at social gatherings, etc. While many writers and cartoonists create their own stationery with computer templates, I find that professional printers do a far better job when it comes to quality. When considering a business card or letterhead design, keep in mind that your column logo or cartoon title should be a part of it.

Though electronic transmission is quickly becoming trade standard, many editors still prefer submissions to be mailed or delivered by courier service in hard copy. Therefore, plan to utilize lots of stamps. To save time, in fact, purchase rolls of a hundred stamps. One syndicate operator I spoke with has taken this part of her business one step further, asking relatives to give her stamps as birthday and holiday gifts—though some still insist on flowers or clothes.

I established an account with United Parcel Service (UPS) many years ago and highly recommend you do the same, for several reasons. First, the daily home pickup saves you time. Second, it is extremely professional when an editor receives an overnight express package. Third, all packages can be tracked. And finally, when everything is considered, the cost is not that much more than utilizing the U.S. Postal Service for similar delivery.

For your column and cartoon packages to appear more professional, you should also include a portrait of yourself. In the past, a mere black-and-white, passport-type photo would have sufficed. Today, a 5″ × 7″ or larger black-and-white or color print and a digital

version of the image on disk are frequently necessary. These are an important part of your "pitch" to editors and should also be used on Web sites, predesigned columns, and, in some cases, even on your letterhead. Don't be stingy with your image—get a professional photographer to do the job; it will pay off in the long run. Before hiring anyone, however, ask if you will be permitted to purchase the negatives. By retaining these, you can have additional prints made at your convenience and for much less than the photographer would normally charge.

Once you have a portrait in digital format, you can import it into your letterhead, your business cards, or your features. This latter practice is common among columnists, though rarely used by cartoonists—who seem to prefer a character from their panel or strip work, and rightly so. What better publicity than a character that will potentially be seen, and recognized, by millions?

Writers that do not use a photograph for their columns should consider a professional logo. If you're producing a fishing column, for example, you might have a drawing of a trout leaping from the water or simply a rod, reel, and fly. Whatever the case may be, photo or graphic design, it should be carried over from your feature to your stationery to create continuity.

Topics
The topic of your column or cartoon should be dictated not only by your personal interests, but also by the market. We've discussed aspects of your market in previous chapters, and the advice offered holds particularly true for the self-syndicator. Frequently, a large syndicate may launch a new artist because what he or she offers fills a hole in the agency's daily lineup. The company name, in this case, often aids in the selling of the work. Most self-syndicated artists cannot afford such luxury. They must be on target from the onset. Syndicated columns, for example, currently number in the thousands and cover a wide variety of interests. The annual *Editor & Publisher Directory of Syndicated Services* (appendix E) provides a complete list of columns in print.

In order to have unlimited marketing potential, your feature, in addition to being unique, needs to cover a broad demographic base. Texans will not want to read about New York politics, although many of them might enjoy cartoons based on Big Apple personalities. On the other hand, they'd probably not appreciate being on the butt end of a humor strip about Texans. You might decide to limit your market, and that is fine, too. If you make such a decision and target a

single demographic area, analyze your income potential before you begin selling yourself. Creating and selling syndicated columns and cartoons is a long-term commitment. An oversight in market size— i.e., excessive limitation in the demographic area in which your work fits—could have a devastating impact on your business. To avoid such a pitfall, insure that you have a wide enough customer base, but not so big that it is beyond your sales capability to approach.

Additionally, your feature must cover a specific topic that interests newspaper readers. The angle will need to be entirely unique, and your style will have to have the readers coming back for more. The most common mistake made by syndication hopefuls is using another artist's concept as their own. If it has been done before, it's not worth doing.

"As with any comic strip [or column], you have to catch the reader's attention," explains Jim Keefe, writer and artist of the successful feature, "Flash Gordon," syndicated by King Features. "I always hear the lament that continuity strips [and columns] don't sell, but look at Lynn Johnston's "For Better or For Worse." She took the gag-a-day format and turned the dailies into a continuity. The story lines have drawn the readers in to where they really care about the characters and read the paper every day to follow their trials and tribulations."

Below, you will find a list of broad topics designed to spark your imagination. Nearly every column and/or comic strip today falls into one of these broad categories. It is now your job to narrow the field. First, write down the areas that interest you most. When you are finished reviewing the list, then edit it down to only five. Next formulate ten different angles you can take with each of these subjects.

After you have listed the different angles, read through them once again. Eliminate the ones you're least interested in. Keep doing this until you have less than five topics remaining. Ponder these for a few days to determine which topic is right for you and the environment in which you will be working—i.e., major city, rural town, coastal area, etc.

Topic Ideas

Politics	Government	Editorials
Satire	Humor	Lifestyle
Global Village	Cooking	Food
Etiquette	Gardening	Health/Fitness
World Affairs	Advice	Automobiles
Money/Finance	Fashion/Style	Do-It-Yourself

Seniors	Singles	Love
Divorce	Animals	Teens
Schools/Curriculum	Genealogy	History
Business	Employment	Careers
Home-Based Business	Books	Movies
Art	Music	Entertainment
Restaurants	New Technology	Internet
Sports	Outdoors	Religion
Travel	Women	Men
Children	Human Interest	Environment
Conservation	Science/Nature	Psychology
Medical	Cartoons	Caricatures
Puzzles	Crosswords	Bridge
Word Games	Supernatural	Spirituality

Types of Syndicated Material

In addition to selecting a topic, artists must ask themselves how they intend to approach the final subject. Writers, for example, might consider the options of a how-to or question-and-answer column. Maybe you'll do reviews or profiles, op-eds or commentaries. Cartoonists must also face these decisions.

Such considerations fall into the category of what "type" of syndication you are interested in. One writer's subject might merit a weekly column, while others—"Ann Landers," "Dear Abby," etc.—could do very well as dailies. Most daily columns, however, are created by more than one person. Producing a daily feature, in fact, is like chaining yourself to a chair in front of your computer and saying good-bye to all other aspects of your life. Most writers, therefore, find that single feature syndication is what they are interested in. I have been syndicating single features for many years and find it an easy extension to freelance work.

Cartoonists have similar decisions to make: Will you do single, box cartoons, or strips? Will it be daily or weekly? Color or black-and-white? While the market will more than likely dictate the latter issue, if you sell to magazines as well as newspapers, you may want to create directly in color.

There is nothing worse than getting yourself involved in daily or weekly syndication only to find that, after a period of time, you lose interest—and are bound by a contract to prostitute yourself to work you have grown to hate. It is, therefore, extremely important that you know exactly the type of syndication you are interested in doing on a long-term basis before getting started.

What's in a Name?

Once your topic and type of syndication is decided, you will need to name your feature. There is no magic formula to successful names. Think, for example, of some of the comic titles used in syndication's most successful efforts: "Peanuts" (what does this word have to do with a group of kids and a dog?), "Shoe," "Hi & Lois," "Hagar the Horrible," "Doonesbury." Columns seem to be a little less creative: "Ask Dr. Ruth"; "Dear Abby"; "Your Home Decorator"; "Dogs, Cats and Other People"; "Gardening Where You Live." All very simple, understandable titles. There are, however, vague titles in syndicated writing as well, such as "A View from the Porch." One could imagine hundreds of topics that such a name could cover, unless they actually read the column. It might discuss home improvement, for instance, or talk about American history—i.e., what the Confederates witnessed from the elegant porches of their southern plantations during the 1860s. As author Linda Mussehl points out, however, the title fits her concept perfectly.

"'A View from the Porch' reflects contemporary country realities and is aimed at the rural and small town newspaper reader. . . . The current popular culture ignores the rural and small town people or stereotypes them as living either on Walden Pond or Green Acres. My column bucks this trend and deals with everyday realities of life in 'The Land Where Domino's Doesn't Deliver.' Most columns are humorous, but with a bite—a bit of attitude."

Your feature title must draw attention, while being as short as possible. Whether you use your name or a pen name as author doesn't really matter, and there may be several good reasons why one might prefer a nom de plume. Some creative individuals even combine their name with the feature topic ("Gardening with Glenda"). Ask your friends and family for ideas, but don't get so wrapped up in their responses that your better judgment becomes blurred.

While the feature name is important—if for no other reason than you may find yourself living with it for many, many years to come—it will be your work that ultimately generates sales and readers. You should, however, be satisfied with the final title.

SUBMISSIONS

The way you approach a newspaper editor with your syndicated cartoon strip or column could make all the difference in winning or losing a client. One of the first considerations you must face is format: What should your work look like; how should it be submitted? When you are syndicated by an agency, it takes care of such details, making sure that all columns are delivered to clients laid out and camera ready. When you self-syndicate, this becomes your responsibility.

Syndicated columns should be formatted in newspaper-column style. That is, your feature should be laid out exactly as it will appear in the newspaper. Be sure the typeface used matches that of industry standard—normally a serif font, such as Times New Roman, at a point size of 9 or 10. Each page should be laid out in two or three columns of text. Your word processor will allow you to do this. Some programs even have newspaper-formatting functions. Check your instruction manual or your computer help screen to see if your machine offers this option. Some self-syndicates eventually hire this work out to secretarial services. If you find yourself in this situation, take a newspaper to your meeting and show them what you want your final product to look like.

Keep in mind, also, how the headings and photos are used throughout the various newspapers you plan to approach. What is the font style and size used for titles? Are images used at the top of columns or as inserts in the actual text? The closer your formatting

matches that of the potential client, the easier it will be for the buying editor to visualize your column in his or her newspaper.

If you will be creating your camera-ready columns on a computer, it is a simple matter to insert your scanned portrait into the formatted text, and even move it around if necessary, prior to printing. On the other hand, if you are using a professional printing or copy service, you will want to leave room in the text for the photo to be inserted.

Cartoonists, unlike writers, frequently find it easier to produce strips in a format twice the size of what will actually be printed. This makes perfect sense, as it gives the artist more room to work. Once a strip is completed, there are two options: have it scanned into a digital format, which can be reduced by a computer and printed out in standard newspaper size—9″ × 4½″ for two-stacked strips—prior to submitting; or take it to a copy shop for reproduction at a 50 percent reduction in size.

Traditionally, the two- and sometimes three-stacked strips are used in Sunday cartoon sections, while weekday editions are normally single strips (measuring 9″ × 2⅜″, including the title). Another difference between the Sunday and weekday comics is color—though more and more newspapers are adding color to their daily editions. For your submissions, a good mix of both color and black-and-white is recommended, to provide the acquisitions editor enough confidence in your talent and ability to fulfill all their needs.

Creating Features

Whether creating cartoon strips or writing columns, you will need at least ten samples to begin your marketing campaign. The constant, day-in-and-day-out requirement for fresh, new material often becomes the most difficult part of syndication work. Editors, too, know this and want to be assured that you will be able to maintain the quality and consistency you promise. Furnishing sufficient samples will provide such insurance.

To get started, make a list of twenty or more feature ideas (or use the list supplied in the previous chapter) and then eliminate those that do not truly appeal to you. This is often easier for the writer than the cartoonist. The latter must frequently do his "thinking" with sketches, while the scribe can add or delete words from a list with the stroke of a pen.

Once you've come up with ten concepts that fit the theme of your feature, it's time to go to work. Perhaps the best advice, at this point, comes from one of the self-syndicated artists I interviewed for this book:

"After you start, do not stop. If you must take a break, stop working in the middle of a feature, rather than between columns or strips. It is much easier to resume a piece in progress than it is to begin anew. Don't give up now! You will eventually finish all of your samples and feel great when you do."

While some people call this the "paying your dues" period, others I spoke with said that with syndication, one must "pay their dues every day of the year."

Traditional syndication calls for columns of the same word length, preferably 500–750 words. It should go without saying that someone else should proofread your material before it is prepared for submission. While family members will suffice, a colleague or editor friend might be best.

Several years ago, I learned the hard way that you should always double-check everything. To make my job easier, I purchased a rubber stamp that goes across every cover sheet (not the one I send out with the completed work, of course) and includes the following:

Column Checklist

___ Let another writer read first draft
___ Do Grammar Check
___ Do Spell Check
___ Ensure word counts are consistent
___ Let someone else read final draft

It seems simple, and is. You would be surprised, though, how many times this list has saved me from major embarrassment and maintained my status as a professional, quality writer.

Like the columnist, the cartoonist must also insure his or her work is of the highest standards. That means double-checking such things as dialogue, spelling, continuity in design and color, strip size, and a flowing story line. In some cases, such as single panel cartoons, this latter area may not apply. If yours is an ongoing comic like "Spider-Man" and "Prince Valiant," however, consistency in story is of utmost importance.

The Sales Approach

There is a debate currently taking place in the syndication industry between traditional methods of submission (i.e., mailing a package of samples) and the utilization of electronic transmissions. Here are two examples of this contrasting view.

The first:

"... young artists and writers who are looking for a career in news-
paper syndication are syndicating themselves via the Internet, which
is how the syndicates are moving their features. The days of proof
sheets are nearly over. Most comics [and features] today are moved
to the client papers electronically. Therefore, it is important to know
each individual paper and the market it serves. It's worth 50 percent
of the profits to do your homework . . . If I was a young creator, I
would definitely self-syndicate." —A VETERAN CARTOONIST

And the second:

"The best approach is to send six to a dozen columns, a cover sheet
explaining the column concept, and a brief autobiography. (Every-
thing by mail, with return postage)."
 —FRED SCHECKER, CREATIVE DIRECTOR, TRIBUNE MEDIA SERVICES

These are the views of one creator and one syndicate editor. But what
do the newspapers—your potential clients—really want? Of those
editors interviewed, 98 percent said that the initial approach should
be a package mailed directly to their office. The electronic submis-
sions, mentioned by our veteran colleague above, will come later,
after you've succeeded in signing a contract with a newspaper. Right
now, your goal is to get to that stage.

When approaching any publication, it is most effective to target
a specific editor by name (i.e., Ms. Mary Jones, Religion Editor; Mr.
Sam Speed, Sports Editor). In most cases, a packet sent to the man-
aging editor will eventually draw a response, but will be passed
around from editor to editor until it finds the appropriate individ-
ual. Turnover in the news industry is tremendous, and keeping
track of all the personnel changes is difficult. Regardless of your
approach, most newspapers will respond to your proposal with a
personal note of acceptance or rejection, and often a phone call to
the same effect.

A proposal packet should contain a cover letter—also called the
query or proposal letter—sample work, spec sheet, and author's biog-
raphy. One self-syndication suggests that "at least four weeks of
comic strips [twenty-eight] should be included. Column samples, on
the other hand, can be as few as six or ten."

Query/Proposal Letter

Your query/proposal letter needs to be as short as possible. In most
cases, this is nothing more than a cover letter introducing the poten-

tial client to you and your feature. The cartoon strips or columns, however, should always speak for themselves.

Inform the editor that you are offering him/her an exclusive option to your work for a given period of time. For instance, forty-five days. What you will be selling is first print rights in the editor's primary circulation area for a flat fee per column. Most syndication sales are based on the insurance that no other publication in the buyer's distribution area will be carrying the same feature. In this way, should the column or strip become extremely popular, you are basically helping boost the newspaper's readership and increase sales over its competition. You should always keep this rivalry in mind when attempting to sell features—and avoid offering the same material to two publications in the same geographical area.

Your goal is to build a one-to-one relationship with newspaper editors, based on quality, reliability, and loyalty. Maintaining these three traits will insure you a long-standing partnership with clients. Starting with a proper cover letter that reveals your personality, as well as your syndication offer, is a good start.

Pricing

One of the most complicated issues of self-syndicating is feature pricing. Some companies charge a fixed, per-feature rate, while others offer package prices. In the latter case, the newspaper may be charged for a certain number of columns or strips, whether they use them or not. Or they might purchase an annual "subscription rate" to your features.

Laid-Back West Syndicate, for example, offers its clients forty columns at $9.95, if provided electronically, and $19.95 if delivered by mail.

Features are almost always priced based on newspaper circulation, with the larger newspapers paying a higher fee than, say, a local paper with few readers. The Captain Food New (CFN) Syndication Service offers its weekly "Guest Chef" feature to publications with under 100,000 circulation for $225 a year. Those newspapers with over 500,000 readers pay $375, while those with more than half-a-million circulation pay $500.

These rates, according to the syndicate's sales material, are for one-time use by a single newspaper. "Corporations wishing to participate in the Captain Food News Syndication Service desiring to purchase . . . for multipaper publication should contact Captain Food News by mail or e-mail to negotiate rates."

Always price realistically. You cannot outprice the large syndicates and expect to maintain business. A 50,000 circulation newspaper might pay a major syndicate $10 a week for a daily feature, while the *New York Times* may be charged $75. Your goal is to get a wide client base—large numbers of newspaper buyers—thus bringing total sales to a good level, rather than trying to get all of your return from a handful of clients. A good initial goal is twenty-five customers. If you average $50 a week per feature, your monthly return will run about $5,000. If your client's distribution is small, however, you cannot expect them to pay so dearly.

To launch a new feature, syndicates will often offer the first ten samples free of charge, or for $1 to $5 each. Readers will often respond to columns or strips by writing directly to the editor. If the response is positive, the editor will want you to continue to provide weekly (or daily, biweekly, monthly) material for his readers. When your relationship is established, you will have sufficient time to discuss price increases.

Proposal Packet

Send your columns or cartoons attached to your proposal letter, spec sheet, and bio with a paper clip. Do not staple your materials together. If the editor wants to share your columns with his colleagues, he will be making copies. Check your packet before sealing to insure you have not sent duplicates of any features. You can enclose a SASE for their return—and make sure the postage is sufficient—if so desired. I recommend, however, sending disposable materials with an SASP (self-addressed, stamped postcard). This will save on postage, while still inviting comments from the editor.

Mailing

Purchase large envelopes so your submissions will arrive flat. You can print your own labels with your word processor or have them professionally made. Whatever the case, your feature logo should appear on EVERYTHING you use: stationery, business cards, envelopes, etc. Use your feature title, not your name, on the return address. Remember, you are a syndication business, and your feature is your product. You want to promote it every way possible—including listing it on your return envelopes.

While on the subject of submission appearance, most successful syndicates provide editors with glossy, professional media packages containing persuasive materials especially designed to make the editor feel good about the new feature. Your offering should be no less

attractive. From the proposal letter to the overview and the samples, everything must be on high-quality stock, designed to perfection, and offered in a presentation folder.

It is worth the investment to seek professional help in designing and printing such materials, if you are not capable of such creativity yourself.

Once your package is ready, author Jennie L. Phipps suggests that self-syndication writers and cartoonists do a mass mailing to newspaper editors.

"Pull together a list of newspapers and editors," says Phipps. "You can buy a mailing list that includes name, e-mail addresses, postal addresses, and phone numbers from Gebbie All-in-One Directory on Disk *(www.gebbieinc.com/disks.htm)* for daily/weekly newspapers. For e-mail only, try U.S. All Media E-mail Directory *(www.owt.com/dircon/)* for newspapers and other media. This service identifies names and e-mail addresses of some key sub-editors. For a really complete listing, including e-mail and postal mail addresses, key editors' names, and phone numbers, buy the *Editor & Publisher International Yearbook* (appendix E), but you'll have to create your own mailing list or buy the CD-ROM version."

Getting Known and Getting Help

While you are submitting your feature packages, you should also give some thought to exposure for your company, your column, and yourself. Once you land a client or two, you qualify for a free listing in *Editor & Publisher's* annual syndication directory. Simply call their listing department at 800-336-4380 and ask how your information should be submitted. At the same time, ask them to send you an advertising kit with current rates. If it fits into your budget, you might consider placing a small (⅛-page) box advertisement. Another option would be to place classified ads in the weekly edition of *Editor & Publisher* magazine, under Services. This publication is read by nearly 80,000 editorial buyers, and the $6.75 per line rate will certainly not damage your budget.

There may come a time when you wonder if you can actually pull off a syndication business. At one time or another, all successful self-syndication wizards have felt such emotion. While the nature of this business does not provide a reservoir of assistance, there is one individual, Jim Toler, who can help. A former sales representative for United Media and Tribune Media Services, Jim offers consultation to artists through his syndication and syndication-assistance company, Toler Media Services. Making sales calls throughout the country, Mr.

Toler places features for clients that he has carefully selected. He also offers editing and marketing advice, reviews features and packaging, and, generally, takes you by the hand until you reach a level of confidence required for self-syndication. For this, Jim normally takes a 10 percent commission on sales. Toler can be contacted by e-mail *(cannaday@global2000.net)* or phone (518-743-0631).

If you'd like to explore cooperative marketing with other self-syndication operators, you should contact The Columnists' Collaborative. Under this heading, artists share the marketing costs—fax, phone, e-mail, postage—and their work is included on a rotating basis to over 3,500 daily and weekly newspapers. There is a $15 monthly fee to be part of the cooperative. More information on The Columnists' Collaborative can be found at *www.askbuild.com/tcc*.

Follow-up

Newspapers often take four to eight weeks to reply to your proposal. If enough time has passed, contact the editors who have not responded. Call or write to inquire if they have received your packet, and ask if it is under consideration. Some editors may be angry that you have interrupted their day, but don't let this bother you. Angela Adair-Hoy, president of Deep South Syndication, put it this way: "I've had a few unpleasant encounters with editors. I remind myself—not them!—what they have obviously forgotten: that they would not have a job without artists. If you do have an unpleasant encounter with an editor, do not contact him further. You can bet you did not get that assignment. Smile and keep going."

Follow-up also means "cultivating" the clients you already have. The sales staff of King Features, Creators.com, and other large agencies spend a great deal of time and money taking editors to lunch, discussing their needs, and passing on the latest industry gossip with clients. You too should try to meet your buyers in person whenever possible. If nothing else, one meeting a year should suffice. Never show up, however, without an appointment. Keep in mind that editors are very busy, and respect that.

Rejection

You will be rejected. Know that right from the beginning. Rejection is usually not a reflection of your artistic talents. Many editors will write, telling you of their budget constraints or high printing costs. In some cases, perhaps this is the true reason for rejection; in others, it is a convenient excuse. Cutbacks and mergers in the newspaper industry are frequent, causing less editorial material to be acquired.

When you do get a personal note of critique on your column or cartoon, read it and learn from it. Make any necessary changes before printing and mailing your next batch of samples. You can only get better. Also, send that editor a personal note thanking him for taking the time to help you with your writing career. Wait a few months, and then send him another proposal. He will remember you, and your chances will be greater for success the next time around.

Your First Sale/Contract

If you are a good and persistent artist, you will become a syndicated newspaper cartoonist or columnist. Whether it be the local paper, or nationwide distribution, you will have your name in print.

Remember that after you have sold first rights in a primary circulation area, you can no longer market your feature to any publication that overlaps that distribution area. If you are uncertain which newspapers are also distributed in the client's area, ask the editor for a list—he can normally tell you off the top of his head.

Some papers may send you a contract—but you should not wait for one to arrive. I recommend sending your own to the newspaper. A very simple sample contract can be found in appendix D. As this agreement states, you are entitled to terminate the existing contract, and approach competing newspapers, if your client newspaper fails to pay you in a timely manner (sixty days). If your column is successful, the editor will not want to lose you and will insure your bills are paid. Should collection action be warranted, give the newspaper ample time to pay before approaching another publication. The newspaper industry is a close-knit world and thrives on gossip. You do not want to be known as a troublesome columnist.

Each new client should have a separate folder in your files. I recommend sending each editor a Client Information Form (appendix D). You can then add the completed form to the client's file folder for quick reference.

Working with Clients

After successfully landing clients, you must insure that you provide your features to them in the format they require. In some cases, although rare, this may be fax. In others, it may be camera-ready slicks or hard copies by mail. Some may want electronic submissions, delivered as attachments to e-mail. Others may ask whether you have a Web site with automatic downloading.

If you provide your cartoons or columns in a quarterly package, as many syndicates do, you may want to offer them on disk in either Mac or IBM formats.

No matter what the option, it is important to fill the need of the customer. Give them what they want and you are that much closer to a pleased client and long-term relationship.

Clips and Fan Mail

A clip is a photocopy (or original) of a feature that has already been published. Request clips of every column or strip published (though your editor will probably just add you to his complimentary sub-scriber list). Once you have accumulated a few clips, you can use these in your marketing packets. Clips are more impressive than the computer-generated samples and should replace them as quickly as possible. Send your ten best clips in all future marketing packets.

Keep in mind that newsprint fades, yellows, and tears over time. Protect your clips by laminating them. You can have them pro-fessionally laminated, or buy inexpensive laminating material from an office supply store and do it yourself. These kits contain adhesive-backed, clear material that is placed on the front and back of your original. The edges can then be trimmed, and your feature can be stored safely.

Nearly every cartoonist and writer receives fan mail. You can turn these letters into marketing tools by selecting the best com-ments and using them on a quotes or "What Readers Say" sheet. If your material is controversial and you anger readers, you have stirred emotion. Readers and editors love controversy. If you have helped someone, or simply made them smile, you have affected that reader. Your critics and fans will keep coming back for more, and edi-tors know this. In addition to creating a comment sheet, you can choose the best letters, photocopy them, and include them with your future marketing packets. Keep a list of all the readers who have taken the time to write to you. They may want to buy a book from you someday.

Realistic Goals

While some artists may have the financial resources and time to do mass submissions, most do not. I can assure you, however, that you can still be successful at self-syndication. The key is to keep realistic goals and establish a submission pattern so that a growing number of potential clients are always reviewing your work.

When I first began syndicating features, I established a very simple system that has paid off over time. After preparing a profes-sional package, I obtained a mailing list of editors and focused on getting my packages into the hands of the first five editors listed.

This was my goal for the first week. The next week, I sent packages to the next five editors. By the end of the month I had twenty submissions out and had already begun to get replies.

I continued this practice religiously, and after one year of business, 240 editors had seen or were in the process of considering my work. By that time a fair number of magazine and newspaper editors had accepted my features, but I insisted on getting five packages out to new editors each week just the same. This is the type of attitude and persistence you, too, need to take to succeed in national syndication.

Your first goal is to get a single editor to buy your work, then two, three, four, . . .

At the same time, you need to be realistic about the expected return. Don't expect an overwhelming acceptance rate. Focus on getting 10 percent. If you can maintain this figure, you will have twenty-four clients in one year. In two years, forty-eight. By the fifth year, if you continue marketing, you should have 120 customers and be averaging about $40,000 a year.

YOU'RE A BUSINESS

ecause self-syndication is something that does not require a corporate office, store front, or major magazine, billboard, radio, or TV advertising, many artists overlook the fact that they are still, technically, operating a business. Everything you do should illustrate that you are a business—from the office equipment to the stationery. Running a business requires that you pay special attention to local, state, and national laws, as well as record keeping. A company must also give consideration to communications, banking, and several other aspects of day-to-day "business" operations.

For most writers and cartoonists, operating as a sole proprietorship is the easiest business structure. Because your marketing goal is to appear as large as possible, however, you may want to look into other company structures. A perfect example of a writer-turned-business is Arizona-based Melanie Johnston.

"Ten years ago," she explains, "I founded Johnston Writing & Design, a sole proprietorship that provides corporate writing and design services to companies large and small. Corporations seem more comfortable dealing with an entity rather than 'this writer I know.' I believe I'm treated with greater respect than if I were simply a 'freelancer,' which unfortunately, to many, means you write for a hobby."

When selecting a business title, you may want to consider a name other than your own—though many of today's top-rated corporations began as family names. Look into names that would have

global impact, something that would fit the new millennium. By example, review some of the multinational company names being used today—CNN International, MSNBC, United Press International, WorldCom—for inspiration and ideas. I also suggest a flashy, eye-catching logo for your self-syndication business.

More information on how you can set up a sole proprietorship in your state, including the DBA ("doing business as"—a name other than your own) rules can be obtained by calling or visiting your local chamber of commerce and/or Better Business Bureau.

Many artists, including myself, have optioned to work as a corporation. Andrew Rosenbaum, a specialist in European business writing, works under the corporate title Allegra Communications. "It offers considerable fiscal and business advantages," he says. "One has much more flexibility in handling social security and taxes. And publishers process invoices from companies differently than those of sole proprietors. And since I do a lot of international work, it simplifies payment."

Personally, I have owned and operated three companies during the past twenty-one years. While paperwork increases when one incorporates, there is certain liability protection with this type of business—particularly as you expand and become more successful. It is extremely simple to set up a corporation, including state and federal registration. In fact, it can be done by phone or Internet. Two organizations offering this service—both of which I have used and highly recommend—are Delaware Registry, Ltd. (800-321-2677) and The Company, Corp. (800-542-2677). Internet users can request information through the appropriate Web sites at *www.delreg.com* and *www.ftsbn.com / ~incorporate / thecompany_corporation.htm*. You can also request information by e-mail at *corp@delreg.com* and *companycorp@ftsbn.com*.

If you decide to incorporate, be sure you fully understand the five types of business structures under this system and select the right one for you. The advisers of Delaware Registry, Ltd. and The Company, Corp. can explain each of these.

Another alternative, which fits the needs of many, is the Limited Liability Company (LLC). As one artist said, "I like that there are no corporate taxes to calculate and pay. And the big plus is that our private assets are protected and separate from the LLC."

A business front is often the only thing separating a "freelancer" from today's top corporate clients. Establishing yourself as a business should, therefore, be priority in your marketing strategy. Once this is accomplished, you can better focus on the challenge of con-

quering new clients for your syndicated work and come up with creative techniques to win over editors. The key factor, for now, is that you begin to think of yourself as a business. For that is what you are, or should be. With this mentality your success will widen like a river that has reached the open sea. Dan Poynter, owner of Para Publishing, put it very simply when he said, "Having a business is just good business."

Internet users can find general small business information, including answers to common questions and 675 searchable pages, at *www.bizproweb.com*. Other sites that offer helpful tips and guidelines for home-businesses include *www.bizoffice.com* and *www.smartbiz.com*.

Doing Business

In my "home office," I have a dedicated phone line, including a toll-free number, a fax machine, two computers—one exclusively dedicated to e-mail—two printers, a standard telephone, and a cellular phone. There is no excuse for a customer not being able to reach me, night or day, in any time zone of the world. I've gone to the trouble to install this equipment because I am a business. As such, I am able to write off the expense of the equipment at tax time. When I have an exceptionally good year—and need tax deductions—I review my office needs for any additions (like a photocopy machine) or upgrades in hardware. For this reason, and the fact that online editors were asking for digital submissions, I added a scanner last year.

Such decisions are all part of the "business" of self-syndication. When I produce an editorial package for a client, I send it by courier. For one thing, using Federal Express, UPS, or DHL allows me to track the packaging through their Internet systems. This has come in handy several times when editors said they did not receive the materials. I simply look up the waybill number, do a search on the carrier's Web page, and come up with the date and time delivered, as well as the person that signed for the package. With this information, editors have always "found" the "lost" shipment. Using a courier service also gives the client a good feeling about doing business with me. It shows professionalism and a business attitude toward my operation.

If you are working with a computer, but have yet to get connected to the Internet, you may want to find a friend who is online. Visit the Juno Web page at: *www.juno.com*. Here you can establish a free—yes, free—e-mail account. You will receive the software, one e-mail account, and no bills. What more could you ask for, and what a cost-effective way to get online.

When you begin selling, you will want to review the check-cashing policies of your bank. In twenty years, I have had eleven bank accounts in various countries, for several different reasons. I first changed financial institutions because the First National Bank of Tennessee insisted on charging me exaggerated fees to deposit Canadian checks. Opening an account in New York resolved this problem. I was told this is because the state borders Canada.

What you will want is a bank that charges a minimal fee to cash foreign checks—particularly if you plan to expand your syndication globally. Because some publications may offer you the option of payment by bank transfer, you may want to ask what charges, if any, there are for such operations.

Last year I received a $100 transfer from Germany, and the U.S. bank took a $25 fee. In the same respect, I transferred $12,000 from my U.S. bank account into my Italian account. On the U.S. side, a $120 fee was charged, and when the money got to Italy, another $90 was subtracted.

Bank fees are one consideration. Naturally, you want the lowest fee possible for check cashing and incoming wire transfers.

Invoicing

Invoicing is a reality of contemporary business. Without invoices, companies—including newspapers—often feel that they are under no obligation to pay for products or services received. You should, therefore, make invoicing a standard procedure in your day-to-day syndication operation.

Most contemporary computer word processing programs include invoice templates, which look professional when printed out.

If you provide features in mailed packages, include an invoice in the submission. If, on the other hand, you submit electronically, immediately send a separate invoice (hard copy, not electronically) upon delivery of the work. To avoid excess paperwork, time, and money, you might decide to invoice on a monthly basis. You will, therefore, receive twelve checks a year, rather than forty-eight. While this may seem like a minor issue when you have one or two clients, when that number reaches one hundred, you'll be issuing 480 invoices a year if you bill weekly, and that, my friend, takes up time.

Taxes

Tax issues for money earned as an independent business are far too complex to get into here. For free help, suggests Julian Block, noted expert and author of several best-selling tax books, there are IRS

publications, particularly Publication 17, *Your Federal Income Tax.* It covers how to fill out Form 1040. Publication 334, *Tax Guide for Small Business,* covers how to fill out Schedule C. Also, Publication 910, *Guide to Tax Services,* lists the various IRS booklets that are available. You can obtain these publications from any local IRS office or by calling 800-TAX-FORM. The forms are also available online at *www.irs.ustreas.gov.*

I also suggest reading Julian Block's *Tax Avoidance Secrets,* a 560-page book available for $19.95 (that's $10 off the bookstore prices) if you write to the author at 3 Washington Square, Larchmont, NY 10538-2032.

As a final note, Block suggests that artists doing business overseas also get a copy of IRS Publication 901, which covers international tax treaties. This publication provides measures that will insure you are not subject to dual taxation when selling your work in certain foreign countries.

More information and tips on taxes for freelance businesspeople can be found at the following Internet Web sites:
www.irs.ustreas.gov
www.dtonline.com
www.hrblock.com/tax/refnd
www.uni.edu/schmidt/tax.html
www.1040.com

Communications

The telephone and fax are two tools most syndicated artists cannot live without. They are also two of the most costly items in any office. Last year, my bills for communications exceeded $600 a month, which prompted me to begin shopping for discount deals. There is so much competition in this sector that you must first know exactly what you need—i.e., phone, fax, Internet, cell phone, etc. Once you have the architecture worked out, contact several companies for a "package" deal. Ask them, also, about tossing in a toll-free telephone number. You'll find savings of up to 60 to 70 percent by shopping around.

10

USING THE INTERNET

The Internet has made self-syndication much easier than it once was. Everyone, from large, international syndicates to tiny, one-person operations are using the Net.

King Features, for instance, offers a "Weekly Service," whereby clients can get columns and cartoons directly from its Web site. As King puts it, "Now available electronically! The world's most successful package for community newspapers and small dailies is now available on our electronic bulletin board! Each week, you can download seventy camera-ready features, including comics. The package is also available on disk. . . . What's more, you get the entire package for one low price—a price most newspapers pay for a single feature!"

To explore the many sales and design possibilities you have as a Web syndicate, take a look at the following sites, which are currently offering features electronically:

www.captainfood.com / syndicatinfo.html
www.cartoonweb.com
www.creators.com
www.kingfeatures.com / features.weekly / weekly.html
www.laid-back.com
www.millerfeatures.com

"The Internet makes it easier to send comics [and features] electronically," says one nationally syndicated artist, "and e-mail makes communication with editors much more accessible. Obtaining names and addresses of client papers and editors requires some research,

but several months of research is worth 50 percent of the net, which is what a [large, national] syndicate charges to sell and process the money."

Simply slapping a Web site on the Net, however, is not sufficient. Your Web site, like your features, will require marketing. Internet publishers that frequent the conference circuit are all too familiar with the words "marketing" and "Internet." Unfortunately, while many hear the words, few actually know how to successfully combine them. They develop banner advertising with Net partners, list their URL on the company letterhead and literature, and work on the tags for major search engines. Where they often fail, however, is in the unsophisticated, grassroots marketing tactics required to triple or quadruple the number of visitors to their sites—and sales of their features.

"Until you can promote your site in a big way," says Zuhair Kashmeri, creator of the Canadian Web management company, Media Minders, "treat it simply as an online glossy brochure that gives potential clients an idea of what you offer. . . ."

Web publishing in itself is a technical business. As such, many of those involved find it difficult to trade the visual glamour and speed-of-light communications for the hands-on, face-to-face marketing methods used by their forefathers. Often times, though, the old ways are the best ways.

"Our site was launched in June of 1997," explains Betsy Burlingame, publisher of Expat Exchange, a site for expatriates around the world. "To date, the site has been mainly promoted by word of mouth and grew from 100 to over 450 users per day. In the past three months, we were reviewed in the *Wall Street Journal,* the *Washington Post* and *HR Magazine.* . . . Network traffic (as a result) has increased 118 percent, and the site users have increased 102 percent."

Though we live in an electronic age, exposure in print media, as this example demonstrates, is still the most effective way to draw people to a Web site. This does not necessarily mean that you should waste money with paid advertisements. In fact, quite the opposite is true. There are two forms of contemporary marketing, no matter what your product: advertising and promotion. The difference between these, very simply, is that you pay for advertising, while promotion is free. Most successful Web publishers utilize a combination of these techniques, though all agree that the latter brings in the greatest results.

Making yourself available for comments and interviews at trade shows is one way in which to reach the media. A more produc-

tive method, however, is through targeted press releases. Eileen Ratnofsky, publicist for Discovery Online *(www.discovery.com)*, owned by Discovery Channel and one of the most successful Web sites on the Internet, says that they develop and send—through both traditional postal and electronic mail—hundreds of releases each year, focusing both on "content as well as the business aspects."

While nearly any aspect of Internet business can be developed into a press release or media kit, the best results often come from newsworthy items—that is, anything new and/or exciting. The launch of a new column or cartoon strip is such an event. This might interest readers of *Editor & Publisher, Publishers Weekly,* and other industry journals read by editors that are potential buyers of your syndicated work.

You should not limit your press release distribution to print media. Two other—perhaps even more powerful—marketing avenues are radio and television. Alan Caruba, founder of The Boring Institute *(www.boringinstitute.com),* says "Having been a public relations consultant for more than two decades, I use promotion, and my most important tool is radio, nationally and worldwide. Over the course of three days, I have done some forty-five radio interviews ranging from major syndicates such as Westwood One to European English language stations such as the Blue Danube Network in Vienna. As a result, one can see an instant spike in hits on The Boring Institute site, because, of course, the Web site is mentioned in each interview."

In recent months, there have been numerous Web personalities, including publishers, on NBC's *Today* and other popular news/talk-shows, discussing a variety of topics—health, money, aging, etc. A popular column or cartoon topic might fit perfectly into the producer's future lineup. In nearly every case, the host says, "You can obtain more information on this topic at the 'XYZ' Web site." There is a very important underlying message in that phrase for syndication entrepreneurs. It tells them to get a press release out to media sources as soon as they begin planning a unique and/or newsworthy topic on their site. Why? Because it allows producers to schedule you as a guest at the same time the information is posted on the Net. The media exposure will create more visitors to your site, which, in turn, enhances potential sales.

Where Do You Go Next?

There are innumerable target markets for a good media kit (which should contain a press release, questions and answers regarding

your site, biographical information, samples of your work, and a photo). Some of these include editors, producers, and corporate executives. Getting media exposure is much like selling a product. You must target the information in your press release or media kit to fit the needs of both the market and yourself. With the proper angle and a good media kit, a savvy PR manager—i.e., you—could easily pitch you as a talk show guest to television producers. The media kit, in this case, could go out to people like Barbara Fight or JoAnne Salzman, producers of *Live with Regis and Kathie Lee* or Mary Alice O'Rourke, supervising producer of NBC's *Today.*

Columnists Katie and Gene Hamilton took advantage of television and radio to launch their writing on home improvement into full-time, profitable careers, including Web publishing.

"We became comfortable doing television and radio interviews a long time ago and have been frequent spokesmen for companies with home improvement products. So promoting our books, newspaper column, and Web site have been very easy and lucrative."

The Hamiltons introduced the Internet site House Net, *(www.housenet.com),* with Katie as the creative director and Gene handling the technical director slot. R.R. Donnelley & Sons later acquired the site, with the agreement that the writing team stays on as employees.

"Talk is hot, whether it's on the radio, TV, or Internet," explains Marilyn Ross, president of Communications Creativity *(www.SPAN-net.org/CC/).* "In 1983, there were only fifty-three radio stations with news/talk formats. The February 1998 issue of *American Demographics* report there are more than a thousand today!"

Two excellent sources for up-to-date lists and information on television and radio talk shows, though there are numerous others, are *Bradley's Guide to Top National TV Talk Shows* and *Book Marketing Update* (Bradley Communications Corp. 135 East Plumstead Avenue, P.O. Box 1206, Lansdowne, PA 19050-8206; 800-989-1400, ext. 432). The latter is a twice-a-month newsletter, perfect for keeping larger directories updated.

Internet Radio/TV Promo—For a Fee

A relatively new business has developed as a result of Internet popularity—showcasing experts for television and radio appearances. While some people shun this type of marketing, others rave about it. One of the companies currently enjoying a fair success—not only in obtaining customers, but in getting them bookings—is Show-Ideas.Com, subtitled "The Online Magazine for Guest & Show Ideas."

Very simply, ShowIdeas.Com creates a marketing site for you and your Web site, within their online archives. The listing contains your name, address, phone number, fax number, e-mail address, your guest availability information, and if appropriate, your specialty and press kit material. Oh yes, there is a fee of $125 per listing.

"Then just sit back and wait for your listing to appear and for journalists to call," explains ShowIdea.Com's instructions to potential clients. "We generally will put new listings on the site within two weeks or less of receiving the required materials."

Each listing is maintained for a minimum of twelve months. The site is operated by Susannah Greenberg Public Relations, 2166 Broadway, Suite 9E, New York, NY 10024. For more information, contact Robert Schechter by e-mail *(bob@bookbuzz.com)* or visit the ShowIdea.Com Web site.

If you're seeking radio gigs, try Radio Tour *(www.RadioTour.com)*. Operated by Broadcast Interview Source, the company reaches out to radio producers and talk show hosts across the country. As their promotion says, "Show the news media you're available. With Radio-Tour.com, we do all the work—and YOU do all the interviews."

There is a $295 fee for this service. For this you get: Web page space on a site frequented by print and broadcast media; your RealAudio® message included on your Radio Tour Web page; a press fax, including your interview availability, to one thousand media outlets; a press e-mail to ten thousand shows and journalists; and guaranteed exposure—or your listing will be run again for free.

For more information, visit the Radio Tour Web site or call 202-333-4904.

A third company offering Internet promotional assistance is KeynotePage *(www.KeynotePage.com)*. "KeynotePage is a full-featured talking Web page that links to and drives business to your main Web site," explain company ads. "Or use KeynotePage to establish your presence on the Web."

Included in the KeynotePage package are: your voice, in RealAudio®—a five minute demo you can record on the phone; contact information; your photo; your text; your topics; and a link to your Web pages. In addition, your page will be indexed in the YearbookNews.com search engine. This was created for journalists seeking interview contacts and has received up to a quarter of a million hits each month.

The fee is $195 per year. To receive greater detail, visit the KeynotePage Web site or call 1-800-KEYNOTE.

Your Future

Through your dedicated, multifaceted efforts, your business will grow. Continue to spend 50 percent of your time marketing yourself and your syndicated work. Don't ever stop. The more you market yourself, the more newspapers you will be in. Once you are established in several papers, set a personal goal to send out at least ten to twenty marketing packets every week. You may also want to consider approaching foreign newspapers with your syndicated features. This aspect is covered in the following chapter.

Ultimately, your success may lead to spin-offs, licensing, and merchandising. For example, the next time you are in a bookstore, take note of the number of titles that are authored by successful columnists and artists. Introducing your work to a book editor may be as simple as sending a one-page letter introducing your feature and your intent to publish in book form. List your total number of client newspapers, and specifically name the larger ones. Include the cumulative circulation of all papers and the average number of letters you receive from readers each week (i.e., "Gardening with Glenda" appears weekly in thirty-seven newspapers including the *Dallas Morning News,* the *San Francisco Chronicle,* etc., with cumulative readership of 1,700,000. In an average week, I receive 125 personal letters from readers and have maintained a database of the readers who have contacted me over the past two years). Include at least ten clips.

You might find, at some point, that your feature has become so popular that you will be approached by manufacturers for licensing and merchandising agreements to use your characters on everything from toys to backpacks. Or maybe your feature will become a movie spin-off. My sincere wish is that such success will come your way. My advice, if it does, is to find yourself a good lawyer.

11

INTERNATIONAL SALES

I decided to "go global" with my self-syndication several years ago, and it was one of the best decisions I have ever made. I've produced, more or less, six hundred features during my career—but I have sold more than three thousand. By going global, I've been able to maintain an average of five sales per feature, and so can you.

Once you have a business mind-set, your next question should be: How do I go about selling my strip, column, or features abroad (i.e., outside North America)? To answer that, let's look at a real-life example. Having lived in southern Italy for many years, I discovered that during the Christmas season, an underwater nativity was placed inside a cave near Sorrento by a local dive club. Illuminated by submerged lights, hundreds of divers visit the display each year.

A perfect story for a dive magazine, I told myself. I could sell it to *Scuba Diver* for, oh, $225. Then I put on my global-businessman hat and began to really think. I could also syndicate first U.K. rights to *Diver* magazine in England. And in Germany, there is a publication called *R&R* for the U.S. military stationed in Europe. What about an in-flight magazine? Don't most weekly newspaper magazines around the world carry stories with Christmas angles?

Though this was a single feature syndication, it could have easily been a cartoon featuring a Christmas theme, or a complete set of holiday columns or strips. Whatever the case, I was thinking globally and looking to international syndication sales.

By the time I was done, I had a list of twenty noncompeting publications to which I sent my package. Ultimately the story sold three times in the United States (1st and 2nd serial, as well as reprint rights), Germany, Italy, Japan, Singapore, South Africa, and the United Kingdom. This single feature brought $3,300—and it is still selling!

The success or failure of your international syndication is up to you. With Internet communications, working for clients in Australia, England, Hong Kong, or South Africa is as easy as servicing editors in New York City. Like a snowball that rolls down a hill getting larger as it goes, the more work you do for editors abroad, the more your agency will become known and the greater the request for your packages will be.

During a recent university seminar, I told a group of artists that "by going global, one can double his income." What does that mean? If your syndicated columns or strips are bringing in $500 a year, you will probably only make $1,000 through world sales. In the same respect, if you earn $30,000 a year in North America, your chances of reaching $60,000 through global sales is excellent. The reason is that you get out of global marketing what you put into it.

If your mind is swimming with questions—Where can I find international markets? How do I sell to foreign newspapers? What about rights? Can I use the Internet to make global sales?—you may very well be on the road to doubling your income. To delve deeper into international sales, I suggest you read *The Writer's and Photographer's Guide to Global Markets* (appendix E). Despite the name, the information provided applies to cartoonists as well. This book will give you everything you'll need to syndicate your work around the world—including newspaper markets and Internet resources.

SYNDICATES

The following is a comprehensive listing of syndication agencies. Where possible, telephone, fax, and e-mail and Web site addresses have been included. In some cases, the syndicates have requested particular information, such as e-mail addresses, not be listed, as they work only through postal submissions. I've made an effort to honor their requests.

A.D. Kahn, Inc.
24901 Northwestern, Suite 316B
Southfield, MI 48075-2207
Tel: 810-355-4100
Fax: 810-356-4344
Fillers, columns, cartoons.

Adventure Features Syndicate
329 Harvey Drive
Glendale, CA 91206
Tel: 818-551-0077
Comics.

American Crossword Federation
P.O. Box 69
Massapequa Park, NY 11762
E-mail: famul87@aol.com
Web: www.newsday.com
Crosswords.

American International Syndicate
1324 North Third Street
St. Joseph, MO 64501
Columns, features.

The American News Service
289 Black Fox Road
Brattleboro, VT 05301
Tel: 802-254-6167
Fax: 802-254-1227
E-mail: pseares@americannews.com or mas@americannews.com
Web: www.americannews.com
Features.

Ampersand Communications
2311 South Bayshore Drive
Miami, FL 33133-4728
E-mail: amprsnd@aol.com
Web: members.aol.com/amprsnd/ampersandcommunications.html
Travel, business, science, health, seniors, food, environment.

Arkin Magazine Syndicate, Inc.
500 Bayview Drive, Suite F
North Miami Beach, FL 33160-4747
Magazine features, columns.

Arthur's International
2613 High Range Drive
Las Vegas, NV 89134
Columns, features, news. No comics.

Black Press Service, Inc.
166 Madison Avenue
New York, NY 10016
Tel: 212-686-6850
Magazine and newspaper columns.

Bootstraps
249 West 21st Street
New York, NY 10011
Newspaper columns only.

Buddy Basch Feature Syndicate
771 West End Avenue
New York, NY 10025-5572
Tel: 212-666-2300
Features, puzzles.

Chicago Sun-Times Features Syndicate
401 North Wabash, Suite 532A
Chicago, IL 60611
Columns, comics, editorial cartoons.

Chronicle Features
870 Market Street, Suite 1011
San Francisco, CA 94102
Tel: 415-777-7212
Newspaper columns.

Clear Creek Features
P.O. Box 35
Rough and Ready, CA 95945
Magazine and newspaper columns.

Community Press Service
P.O. Box 639
Frankfort, KY 40602
Tel: 502-223-1736
Fax: 502-223-2679
Newspaper columns, features and fillers, single-panel cartoons.

Continental Features/Continental News Service
501 West Broadway, Suite 265, Plaza A
San Diego, CA 92101-3802
Tel: 619-492-8696
Features, news.

Copley News Service
P.O. Box 120190
San Diego, CA 92108
Tel: 619-293-1818
Fax: 619-293-3233
E-mail: copleysd@copleynews.com
Web: www.copleynews.com
Newspaper columns, features, fillers.

Create-a-Craft
P.O. Box 330008
Ft. Worth, TX 76163
Columns, features, comic strips.

Creative Syndication Services
P.O. Box 40
Eureka, MO 63025-0040
Tel: 314-587-7126
Magazine and newspaper columns on crafts.

Creators Syndicate, Inc.
5777 West Century Blvd., Suite 700
Los Angeles, CA 90045
Tel: 310-337-7003
Web: www.creators.com
Newspaper columns.

Cricket Communications
P.O. Box 527
Ardmore, PA 19003-0527
Tel: 610-789-2480
Fax: 610-924-9159
E-mail: 76550.42@compuserve.com
Magazine and newspaper columns on small business and finance.

Crown Syndicate, Inc.
P.O. Box 99126
Seattle, WA 98199
Newspaper columns on trivia.

Dany News Service
22 Lesley Drive
Syosset, NY 11791
Newspaper columns on parenting.

Dorsey Communications
9239 Donery Road
Los Angeles, CA 90069
Tel: 310-273-2245
Fillers, news, features, columns.

Editorial Consultant Service
P.O. Box 524
West Hempstead, NY 11552-1206
Tel/Fax: 516-481-5487
Magazine and newspaper columns on automotive topics.

Extra Mile
Box 345
Valley View, PA 17983
Columns, features dealing with motor sports.

Fotopress
P.O. Box 1268, Station Q
Toronto, Ontario
M4T 2P4, Canada
Magazine and newspaper columns on environment, art, and travel.

Hispanic Link News Service
1420 N Street, NW
Washington, DC 20005
Tel: 202-234-0280
Fax: 202-234-4090
E-mail: zapoteco@aol.com
Newspaper columns and features.

Hollywood Inside Syndicate
P.O. Box 49957
Los Angeles, CA 90049-0957
Tel/Fax: 909-672-8459
E-mail: hollywood@ez2.net
Web: www.ez2.net/hollywood
Newspaper columns on the motion picture industry, personalities, celebrities, entertainment.

International Photo News
226 South B Street
Lake Worth, FL 33400
Magazine columns on celebrities, newspaper columns on politics and celebrities.

International Puzzle Features
740 Van Rensselaer Avenue
Niagara Falls, NY 14305
Word puzzles.

Interpress of London and New York
400 Madison Avenue
New York, NY 10017
Tel: 212-832-2839
Features.

King Features Syndicate
235 East 45th Street
New York, NY 10017
Tel: 212-455-4000
Web: www.kingfeatures.com
Features, columns, cartoons.

Laid-Back West Syndicate
P.O. Box 712
Perryton, TX 79070
Tel: 806-435-4802
Fax: 806-435-7611
E-mail: laidback@ren.net
Web: www.laid-back.com
Columns, cartoons, book reviews.

Lew Little Enterprises, Inc.
P.O. Box 47
Bisbee, AZ 85603
Tel: 602-432-8003
Features, columns, comics.

Los Angeles Times Syndicate
218 West Spring Street
Los Angeles, CA 90012
Tel: 213-237-7987
E-mail: timly@newscom.com
Web: www.lats.com
Newspaper columns and comics.

Jerry D. Mead Enterprises
P.O. Box 2796
Carson City, NV 89702
Magazine and newspaper columns.

Midwest Features, Inc.
P.O. Box 259907
Madison, WI 53725-9907
Columns.

National News Bureau
P.O. Box 43039
Philadelphia, PA 19129-0628
Tel. 215-546-8088
Features.

New Living
P.O. Box 1519
Stony Brook, NY 11790
Tel: 516-981-7232
Magazine and newspaper columns on health, fitness, food, nutrition, sports medicine, and many sports.

New York Times Syndicate
122 East 42nd Street
New York, NY 10168
E-mail: stick@nytimes.com
Web: nytsyn.com
Features.

Press Associates, Inc.
815 15th Street, N.W.
Washington, DC 20005
Tel: 202-638-0444
Columns, features.

Royal Features
P.O. Box 58174
Houston, TX 77258
Tel: 281-532-2145
Magazine and newspaper columns. No cartoons.

Scripps Howard New Service
1090 Vermont Avenue, NW
Washington, DC 20005
Op-eds, commentaries, opinions, news articles.

Specialty Features Syndicate
17255 Redford Avenue
Detroit, MI 48219
Features, article series.

The Sports Network
701 Masons Mill
Huntington Valley, PA 19006
Tel: 215-947-2400
Fax: 215-942-7647
E-mail: tsnwire@aol.com or kenlane/@compuserve.com
Web: www.sportsnetwork.com
Magazine and newspaper columns on professional sports teams.

Senior Wire
Clear Mountain Communications
2377 Elm Street
Denver, CO 80207
Tel: 303-355-3882
Fax: 303-355-2720
E-mail: clearmountain@compuserve.com
Features.

Syndicated News Service
232 Post Avenue
Rochester, NY 14619-1398
Tel: 716-328-2144
Fax: 716-328-7018
E-mail: SWS@rochgte.fidonet.org or sns3@aol.com
Web: users.aol.com/sns3/snsguide.htm
Features, fillers, columns.

Tribune Media Services
435 North Michigan Avenue, Suite 1400
Chicago, IL 60611
Tel: 312-222-4444
E-mail: tms@tribune.com or mmathes@tribune.com
Web: www.tms.tribune.com or www.comicspage.com
Newspaper columns and comics.

United Feature Syndicate and Newspaper Enterprise Association
200 Madison Avenue, 4th Floor
New York, NY 10016
Tel: 212-293-8500
E-mail: syndicate@unitedmedia.com
Web: www.unitedmedia.com
Features, columns, cartoons.

Universal Press Syndicate
4520 Main Street, Suite 700
Kansas City, MO 64111
Tel: 816-932-6600
E-mail: nmeis@uexpress.com
Web: www.uexpress.com
Newspaper columns, cartoons.

Whitegate Features Syndicate
71 Faunce Drive
Providence, RI 02906
Tel: 401-274-2149
Magazine and newspaper columns, comics.

World News Syndicate, Ltd.
P.O. Box 419
Hollywood, CA 90078-0419
Tel/Fax: 213-469-2333
Newspaper columns.

UNIVERSAL PRESS SYNDICATE BOILERPLATE CONTRACT

AGREEMENT

Name:

Date:

Dear :

The following comprises the agreement between Universal Press Syndicate ("Syndicate") and you ("Producer") regarding our syndication of your Feature:

1) PREPARATION OF THE FEATURE. The Producer shall prepare and furnish to the Syndicate each week during the term of this agreement, at such time prior to the Syndicate's date of release as is specified in Section 12 or otherwise as the Syndicate may reasonably specify from time to time, the following material (which, with its drawings, ideas, subject matter, format, continuity, plots, themes, characters, and characterizations, is sometimes referred to as the "Feature"):

The Producer shall maintain for the Feature a quality of work consistent with that previously submitted and with the Syndicate's reasonable requirements. The title of the Feature may be changed by mutual agreement of the Producer and the Syndicate.

The original of any drawing (or text) delivered by the Producer to the Syndicate shall be the property of the Producer, and after any such drawing has served the Syndicate's purposes, it shall be returned to the Producer. No drawing (or text) so returned shall be published or otherwise used in any way or form which conflicts with the Syndicate's rights under this agreement, and the return of any such drawing (or text) shall not in any way affect such rights.

2) SYNDICATION. The Syndicate shall, in a manner consistent with customary practice in the conduct of its business, use its best efforts to sell the Feature to newspapers (both print and electronic) and shall take such other action, if any, to exploit the Feature as the Syndicate in its sole discretion deems appropriate. The Syndicate shall have absolute discretion in selecting purchasers of any rights in the Feature and in determining prices and all other terms of sale in any media. All or any part of the Syndicate's rights under this agreement may be delegated or redelegated from time to time to any sales, syndication, publication, or other agency or firm, each of which may act with respect to the delegated right in its or their own name or names.

3) RIGHTS GRANTED SYNDICATE. (a) The Syndicate shall have, and the Producer hereby transfers and conveys to the Syndicate, all copyright, proprietary, and exploitation rights whatsoever in the Feature produced for the Syndicate by the Producer during the term of this agreement, including but not limited to the following exclusive rights: to reproduce the Feature in copies or phonorecords; to prepare derivative works based on the Feature; to distribute copies or phonorecords of the Feature to the public by sale or other transfer of ownership, or by rental, lease, or lending; to perform the Feature publicly; to display the Feature publicly; to trademark any name or title used in connection with any services rendered or Feature prepared or furnished under this agreement; to copyright any such Feature and to secure any renewal of copyright permitted by law; to communicate the Feature by radio broadcasting, rebroadcasting, wired radio, television, cable, telephone, satellite, or by any other methods or means (now or hereafter existing) of transmitting or delivering ideas, sounds, words, images, or pictures; and to vend and otherwise dispose of, and to otherwise exercise with reference to said Feature, any and all rights and privileges now and [sic] in existence or which may hereafter accrue. As used in this Section 3(a), the term "Feature" includes any derivative work based on the Feature. The Syndicate may, at its option, appoint an agent or agents to exploit one or more of the rights so granted. Whenever requested by the Syndicate, the Producer shall execute any instruments

which in the judgment of the Syndicate may be necessary or desirable to secure to the Syndicate the rights granted by the agreement.

(b) The Syndicate, and its subscribers, agents and appointees, licensees, and successors shall have the right to use the Producer's name, picture (color and black-and-white, provided by the Producer), and biography for promotion, trade, and advertising purposes in connection with the rights granted the Syndicate hereunder.

4) EDITING: FAILURE TO DELIVER. The Syndicate shall have the general editorial supervision of the Feature, but the Syndicate shall make no substantive changes to the Feature without the Producer's prior approval. If the Syndicate determines that a particular installment of the Feature is not suitable for publication, it shall return it to the Producer for revision and resubmission. Upon the inability (whether due to disability, death, or otherwise) or the failure of the Producer to submit the Feature, suitable for publication, as determined by the Syndicate, within such time in advance of the date of publication as the Syndicate specifies pursuant to Section 1 or Section 12, the Syndicate shall have the right, in addition to any other rights and remedies hereunder: (a) in the case of late submission, to deduct from the amounts payable to Producer under this agreement all costs and expenses occasioned by such late submission (including, without limitation, freight, mailing and handling, and overtime of personnel), and (b) in the case of nonsubmission, to have the Feature prepared by others, deducting the expenses incurred by it in this connection, including the compensation of a substitute writer or artist, from any amounts payable to the Producer under this agreement.

5) PRODUCER'S WARRANTIES AND INDEMNIFICATION. The Producer represents, warrants, and agrees, to and with the Syndicate and its assignees and agents, that (except to the extent attributable to editing by the Syndicate which was not approved by the Producer) all material furnished pursuant to this agreement will be original with him and that the use of such material as contemplated by this agreement will not constitute libel or conflict with or infringe upon any copyright, right of privacy, or other rights of any third person or firm. The Producer will indemnify the Syndicate (and any sales, syndication, publication, or other agency or firm to which the Syndicate has delegated rights under this agreement) against any expenses or damages (including reasonable attorneys' fees) resulting from any breach or alleged breach of such representation and warranty. The Syndicate and any such indemnified party shall have the right, at their discretion, either to defend any claim or suit by counsel of

their choice or to settle the same on such terms as they deem advisable. In the event that a final judgment dismissing any such claim or suit without liability to the Syndicate or any such indemnified party, the obligation of the Producer shall be limited to reimbursing the Syndicate and such indemnified party for one-half of all expenses incurred by them in connection therewith.

6) EXCLUSIVITY: RIGHTS OF FIRST REFUSAL. During the term of this agreement, the Producer will not, without the prior written consent of the Syndicate, produce or consent to be produced (under his name or any other name or names), or advise or assist in any way with the production of, any material of similar name or appearance to the Feature for publication in any newspaper, periodical, book, or other publication. The Syndicate shall have the option to meet any bona fide offer for the services of the Producer with respect to material suitable for syndication during the term of this agreement, provided, however, that such option shall be exercised by the Syndicate within 90 days after receipt of written notice of such a bona fide offer.

7) PAYMENT TO PRODUCER. (a) In consideration of the satisfactory performance by the Producer of his obligation under this agreement, the Syndicate shall pay to the Producer, not later than the twentieth day of each month:

(i) with respect to the sale for newspaper publication within the continental United States of the rights to the use of the Feature, 50 percent of the net domestic newspaper collections during the preceding month (derived by deducting from the gross collections from such sales the Syndicate's cost for in-paper promotion, sales and promotional kits, sales and commissions [not in excess of 2 percent], production, transportation by wire or other mechanical or electronic means, securing and protecting trademark and copyright in connection therewith);

(ii) with respect to the sale for newspaper publication outside the continental United States of the rights to the use of the Feature, 50 percent of the net foreign newspaper collections during the preceding month (derived by deducting from the gross collections from such sale the Syndicate's costs for agent's fees and commissions, in-paper promotion, production, trademark, copyright, and all other expenses and payments in connection therewith);

(iii) with respect to the sale of pamphlet compilations of the Feature by advertisements in the syndicated newspaper version of the Feature, 15 percent of the retail list price of each such pamphlet sold; and

(iv) with respect to the sale of any other rights to use, in any media or form other than newspaper publication or pamphlet sale of the Feature, or of its drawings (or text), continuity, ideas, format, plots, themes, characters, or characterizations, 50 percent of the net collections (derived by deducting from the gross collections from such sales all of the Syndicate's expenses [including without limitation agency fees and commissions] in connection therewith).

(b) The Syndicate shall render to the Producer monthly itemized statements (with remittances) of the income and disbursements of the preceding calendar month with regard to the Feature; and the Syndicate's records relating to the Feature shall be available to the Producer or his authorized Certified Public Accountants for inspection at all reasonable times during business hours.

8) PERSONAL APPEARANCES. The Syndicate will act as the Producer's nonexclusive representative in connection with requests for personal appearances or personal services by the Producer, such as lectures, speaking engagements, television or other media appearances, or advertising, product endorsements, and the like, and the Syndicate will not arrange any such appearances or services for the Producer without first securing his approval, which he will not withhold unreasonably. The Producer will notify the Syndicate promptly of his approval or disapproval of the terms of appearances or services submitted to him. The Producer will pay to the Syndicate 20 percent of all amounts, after deducting therefrom his direct and necessary expenses incurred, which he receives for any such personal appearances or services, such payments to be made promptly after receipt of such amounts by the Producer.

9) TERM AND TERMINATION. (a) The term of this agreement shall commence on the date hereof and end on the date ten calendar years from the date of first publication of the Feature in a newspaper, except that such term shall be automatically renewed for an additional period of ten years if the Syndicate's gross weekly billings during the first six months of the last year of the original ten-year term for the sale of the Feature and other rights granted pursuant to this agreement average at least $.

(b) Beginning with the thirteenth month after the date of the first publication of the Feature in a newspaper, if the aggregate payment to the Producer (prior to any deductions pursuant to Sections 4 and 7) under this agreement during any calendar month averages less than $ per week,

either the Producer or the Syndicate may cancel this agreement upon at least 30 days notice to the other, given within the month following the month of such occurrence. Should the Producer elect to so terminate, the Syndicate may continue this agreement by advancing to the Producer a sum equal to the difference between $ and the aggregate payments due to the Producer (after any deductions pursuant to Sections 4 and 7) for the month upon which such election is based, and repayment of any such advance shall be made solely from subsequent payments due the Producer hereunder. No such advance shall constitute a waiver of either the Producer's or the Syndicate's right to cancel upon subsequent recurrences of the contingency provided for herein.

(c) Upon any termination of this agreement, whether by expiration or otherwise:

(i) If there are at the time of such termination any outstanding contracts to third parties respecting any rights hereunder, the Syndicate shall continue to receive the proceeds therefrom, and shall make payments to the Producer in accordance with Section 7, until such contracts are terminated. Section 9(b) shall not be applicable.

(ii) The Syndicate shall have the exclusive right to republish or cause republication in any media of all material delivered to it during the term of this agreement, provided that payment is made to Producer with respect to any republication in accordance with Section 7. Section 9(b) shall not be applicable.

10) ASSIGNMENT, ETC. This agreement shall be binding upon and inure to the benefits of the parties hereto and their respective heirs, legal representatives, successors, and assigns, except that this agreement may not be assigned by the Producer except (a) to a corporation formed by the Producer of which all of the voting stock is owned and continues to be owned by him, and (b) where the Producer continues to be the person who prepares the Feature.

11) BOOK PUBLISHING AND LICENSING. The Syndicate is affiliated with a book publishing firm, Andrews & McMeel ("A&M"), and with a licensing firm, Universal Licensing, Inc. ("ULC"), and the Syndicate may (but need not), pursuant to rights granted it by this agreement, contract with either A&M or ULC for publication or other uses respecting the Feature. In this connection, the Syndicate will not so contract with either affiliate except on terms which (a) considering all circumstances, in the Syndicate's reasonable judgment are as favorable as could be obtained

from an unaffiliated party, and (b) provide creative control to the Producer and the Syndicate. Receipts by the Syndicate from either affiliate pursuant to any such contract will be subject to the payment provisions of this agreement.

12) TIME OF DELIVERY. The time of delivery of installments of the Feature shall be set forth below or, if no time is specified, such delivery shall be as is reasonably specified by the Syndicate from time to time:

Time is of the essence as to this Section, and Section 4 contains certain provisions for deductions for costs occasioned by Producer's failure to meet delivery times.

13) PRODUCT AGREEMENT. Producer acknowledges that this agreement is not a personal services or employment agreement and that the Producer is an independent contractor and not an employee of the Syndicate.

14) GOVERNING LAW. This agreement shall be governed by the laws of the State of Missouri as to all matters including, without limitation, matters of validity, construction, effect, and performance.

15) MISCELLANEOUS. If there is more than one Producer, the term "Producer" herein shall mean all of them, their obligations under this agreement shall be joint and several, and any payment due them hereunder shall be equally divided among them unless they otherwise specify by notice in writing to the Syndicate. The section headings herein are for reference only and shall not be considered in interpreting this agreement. The provisions of this agreement constitute the entire understanding of the parties hereto, and this agreement may not be amended, modified, or discharged except in writing. The waiver of any party hereto to a breach of any provision of this agreement shall not operate or be construed as a waiver of any subsequent breach by any party.

To indicate your acceptance of and agreement to the foregoing, please sign and return to us the enclosed copies of this agreement.

Very truly yours,

UNIVERSAL PRESS SYNDICATE

By _____

The foregoing is accepted and agreed to as of the date hereof.

(Producer)

(Producer's Social Security Number)

(Producer's Date of Birth)

CONTRACT ANALYSIS

By Stuart Rees *(STU@STUS.COM)*

Note: While this appendix refers to "the artist," the information is equally valid for columns.

The first thing to notice about syndicate contracts is that they are always written by the syndicate. This makes sense, because the syndicates know the business best and can spread the drafting costs by using the same template with all artists. Still, as noted throughout this section, the artist must be aware of the meaning behind numerous word choices. Possibly even more important than analyzing what's in syndicate contracts, this review notes the many instances where the syndicates leave out important issues and how that omission works against the artist. Even a sharp artist who understands the legal impact of each provision in his syndicate contract may well miss these subtle issues that never make it into the contract.

The suggestions provided may appear unrealistically detailed. Many artists might state that they lack both the negotiating strength (and the money for an attorney) to revise boilerplate contracts so substantially. With regard to the artist affording the time of an attorney to negotiate the contract, the hope is that this paper is thorough enough to permit artists to handle many issues personally, as well as to know when legal advice is truly needed.

With regard to negotiating strength, it is certainly true that no artist could fully implement these suggestions. Nor is that the goal of this analysis. This review, therefore, covers all issues with the understanding that different artists will use it to get concessions on different issues, so all issues need to be covered. Further, thorough analysis improves the chance that the different possible contract terms of each major syndicate will be addressed. Full implementation of this paper's suggestions might, in fact, make the contract unfair to the syndicate in some cases.

The smaller sans serif text indicates an excerpt from the Universal Press Syndicate's contract. All sections of the contract are in precisely the same order as in the actual contract, but these sections are often cut into smaller pieces in order to isolate specific legal issues. The smaller italic text indicates suggested alternative wording. The contract refers to the artist as "Producer" and Universal Press Syndicate as "Syndicate." The Universal contract was compared to that of many other syndicates. (An original copy of the UPS boilerplate contract can be found in appendix B.) Material differences among the syndicates are discussed in detail.

Section 1: Preparation of the Feature

The first provision of the contract is an innocuous identification of the feature.

1) PREPARATION OF THE FEATURE. The Producer shall prepare and furnish to the Syndicate each week during the term of this agreement, at such time prior to the Syndicate's date of release as is specified in Section 12 or otherwise as the Syndicate may reasonably specify from time to time, the following material (which, with its drawings, ideas, subject matter, format, continuity, plots, themes, characters, and characterizations, is sometimes referred to as the "Feature").

The reason Universal seems to over-define the feature as anything conceivably related to the column or strip is so that it is clear that the agreement encompasses all rights. Otherwise, an artist might feel that certain tangential elements of the column or strip, such as spin-off characters or books, fall outside the contract. This is the first example of the syndicate using the contract not only to allocate rights, but also to explain them to the artists.

The next provision addresses concerns of both the syndicate executive and newspaper editors—they worry about either a drop in the quality of the artist's work or a change in its subject matter.

> The Producer shall maintain for the Feature a quality of work
> consistent with that previously submitted and with the Syndicate's
> reasonable requirements.

This is the first of several provisions through which the syndicate seeks to exert some editorial control. The syndicate can point to the clause in order to browbeat the artist into working harder or modifying the subject matter. In more extreme cases, if the syndicate has the right to have other artists prepare the work (see section 4), then the syndicate could use the two provisions together to bypass the artist. Syndicates are unlikely to take such dramatic anti-artist measures, but it is possible and may be threatened if relations sour. If the issue were to go to court, proving either a drop in quality or the reasonableness of a syndicate's requirements would be an extremely difficult factual investigation. On the other hand, even successful artists would be hard pressed financially to defend a court action against a wealthy syndicate. Overall, this provision sets the tone for the type and quality of work an artist should produce, but it would be employed only as a last-ditch weapon.

The next provision recognizes that the artist and the syndicate are likely to have a vested interest in the title of a feature. From a business standpoint, the title of a comic is like a brand name or trademark. From an artistic standpoint, titles may be a part of the artist's artistic expression. The following provision acknowledges the "mutual" interest of both parties.

> The title of the Feature may be changed by mutual agreement of
> the Producer and the Syndicate.

Other syndicates merely require that the syndicate consult with the artist, but do not seem to give the artist veto power. Adding the word "only" to the Universal contract language would clarify that the consent of both parties is necessary to make a title change.

> The title of the Feature may be changed only by mutual
> agreement of the Producer and the Syndicate.

This type of modification may seem of very small importance, and it is. It also costs nothing to make the clarification, so there is no reason not to be clear.

The next provision, pertaining primarily to cartoonists, addresses ownership of the original artwork drawn by the artist. In recent years, sales of original comic strip art (and the works of famous writers) have begun to occur in art galleries and special auc-

tions. The price typically ranges from $100 to $500, so the issue is not trivial. Here, Universal releases any claim to these originals.

> The original of any drawing delivered by the Producer to the Syndicate shall be the property of the Producer, and after any such drawing has served the Syndicate's purposes, it shall be returned to the Producer. No drawing so returned shall be published or otherwise used in any way or form which conflicts with the Syndicate's rights under this agreement, and the return of any such drawing shall not in any way affect such rights.

Many syndicates follow Universal's lead, recognizing that artists have a fairly strong moral claim to their actual art. But the practice is not industrywide. Some syndicates retain 50 percent of originals in typical contracts, although the negotiations typically settle at 10 to 20 percent, and the artist selects which to surrender. Syndicates typically use originals as promotional gifts to newspaper editors and others, so in certain respects, they are still used to the artist's advantage. But the syndicate does not need more than 10 percent for this.

The only significant issue with the Universal language is that a new clause should clarify that the artist retains the right to possession at all times when his method of delivering the feature is electronic rather than through the mailing of original art.

Although one might be inclined to quibble over the lack of precision in the language *"after any such drawing has served the Syndicate's purpose,"* this will likely become a negligible issue as electronic submission becomes standard.

After incorporating the electronic submission change, the paragraph would read as follows:

> *The original of any drawing delivered by the Producer to the Syndicate shall be the property of the Producer, and after any such drawing has served the Syndicate's purposes, it shall be returned to the Producer. In the event that the Producer makes electronic delivery of the Feature which is satisfactory to the Syndicate, the Producer shall be entitled to continuous possession of his original work. No drawing returned or retained shall be published or otherwise used in any way or form which conflicts with the Syndicate's rights under this agreement, and the return or retention of any such drawing shall not in any way affect such rights.*

It is interesting to note that Universal includes a sentence to state that artist's ownership of the original work does not affect the trans-

fer of any other rights to the Syndicate. This is an obvious attempt to educate the artists as to the operation of copyright law, which states that ownership of original art does not give the holder the right to publish reproductions. This is effective draftsmanship. By stating the law, the syndicate prevents any later misunderstandings with the artist.

Section 2: Syndication

This provision, which fixes the duty owed by the syndicate to the artist, is one of the most important parts of the contract.

> 2) SYNDICATION. The Syndicate shall, in a manner consistent with customary practice in the conduct of its business, use its best efforts to sell the Feature to newspapers (both print and electronic) and shall take such other action, if any, to exploit the Feature as the Syndicate in its sole discretion deems appropriate.

Many serious artist complaints boil down to a claim that the syndicate is not properly managing the feature with regard to either sales or licensing.

The exact duty owed by the syndicates to artists varies among the syndicate contracts. Some small syndicates grant an unqualified "best efforts" clause. On the other end of the spectrum, many syndicates promise only "reasonable effort" or completely deny any responsibility. Universal's wording is substantially more complex; it is divided into a section regarding syndication sales and a section regarding everything else, such as licensing and reprint rights sales.

The first half of the Universal sentence addresses syndication sales. The difference from the other syndicates is that Universal ties its duty to the *"customary practice in the conduct of its business."* The first ambiguity is whether Universal means the customary practice of Universal or the customary practice of the syndicate industry. This is probably an unimportant question, given that the syndicates all operate in a roughly similar fashion and, in either case, the artist is prevented from demanding special attention. The important point here is that Universal recognizes that a "best efforts" clause can have real teeth. A good lawyer for an artist could make a strong argument for judging the syndicate's efforts on some objective scale that is stricter than common syndicate industry practice. Thus, Universal wisely inserts language that prevents such claims. Universal's "best efforts" clause actually means "the Syndicate shall sell the Feature to newspapers (both print and electronic) in a manner consistent with good practice in the syndication industry."

The second half of the Universal sentence is even more interesting, because it disavows any duty for work other than newspaper syndication, such as licensing and reprint rights sales. To someone unfamiliar with the industry, this denial of any standard of duty may seem surprising, but to insiders it makes sense based on the way the syndicates operate.

Universal recognizes that its strength and interest lies in selling to newspapers, and not in merchandising. The question is whether the artist should be granting exclusive merchandising rights to the syndicate if the syndicate does not intend to make "best efforts" use of them, or at least "reasonable efforts." Typically, syndicates will not release their entire interest in licensing and merchandising rights. However, they will usually agree to some compromise, such as either (a) they surrender the rights if they don't generate revenue in excess of a stated dollar amount by the fifth year of the contract, or (b) the artist owns the rights to licensing and merchandising, but must pay the syndicate a percentage, such as 25 percent, of any net revenue generated (basically, the reverse of the normal practice, where the syndicate finds deals and pays the artists a percentage).

The next provision addresses the syndicate's main function of selling to newspapers, so it is less controversial.

> The Syndicate shall have absolute discretion in selecting purchasers of any rights in the Feature and in determining prices and all other terms of sale in any media.

All syndicate contracts have similar language. It make sense that the syndicates feel strongly that their artists should not be second-guessing or pestering them over the details of each sale. Many artists actually like the fact that they get to do the "fun" part of creating and can pass off the business details to the experts—the syndicates.

However, Universal's contract language goes one step further into more controversial territory. The contract also allows the syndicate to license any merchandise without artist approval. Virtually all artists want the revenue generated by license contracts. However, most artists feel attached to their creations and want approval rights to insure the integrity of their art. Some syndicates grant such rights on the condition that approval not be unreasonably withheld. Even syndicates that typically have absolute rights to license are often sensitive to the issue of artistic control. A revised provision that is fair to both parties might look like this:

The Syndicate shall have absolute discretion in selecting
newspapers and other purchasers of the Feature and in determining
prices and all other terms of sale. The Syndicate may license or sell
subsidiary rights in the feature, such as merchandise, provided that
the Producer approves or fails to disapprove the proposed contract
within ten (10) business days. Producer shall not unreasonably
withhold such approval.

The syndicates may not want the annoyance of having to ask permission of artists for each licensing deal, but at least they understand the artist's position and are less likely to be offended by this request than by others.

The syndicate also wishes free transferability of its rights in the event that another party can perform the job better or will pay highly for the opportunity.

All or any part of the Syndicate's rights under this agreement
may be delegated or redelegated from time to time to any sales,
syndication, publication, or other agency or firm, each of which may
act with respect to the delegated right in its or their own name or
names.

This free transferability provision may help the artist. For example, smaller syndicates sometimes enter a sales agreement with a large syndicate that has a better sales force, as was the case recently with Chronicle Features before it was sold. On the other hand, the artist may have entered into the contract with the particular syndicate because he liked its personnel, capabilities, or atmosphere. Subcontracting by the syndicate may ruin any or all of these.

In this era of corporate restructuring and outsourcing, the syndicates are likely to feel very strongly about such provisions. Granting the artist any right of approval would create barriers to both the sale and the most efficient operation of the syndicate. Very few artists have the power to negotiate such a concession, and those who do should probably save their bargaining chips for other issues. For the artist, the best remedy for ownership or personnel problems is to own his copyright and have a short enough term on the contract to permit leaving a problem situation within a reasonable number of years.

The flip side of the syndicate's right to delegate is that the syndicate remains responsible for any delegated duties unless the artist actually releases the syndicate. Thus, if the third party exercising the syndicate's rights or servicing the syndicate's duties violates the artist/syndicate contract, the syndicate remains liable to the artist.

Section 3: Rights Granted Syndicate

This provision allocates ownership of the copyright and defines the scope of the syndicate's rights. This is the heart of the contract.

> 3) RIGHTS GRANTED SYNDICATE. (a) The Syndicate shall have, and the Producer hereby transfers and conveys to the Syndicate, all copyright, proprietary, and exploitation rights whatsoever in the Feature produced for the Syndicate by the Producer during the term of this agreement, including but not limited to the following exclusive rights: to reproduce the Feature in copies or phonorecords; to prepare derivative works based on the Feature; to distribute copies or phonorecords of the Feature to the public by sale or other transfer of ownership, or by rental, lease, or lending; to perform the Feature publicly; to display the Feature publicly; to trademark any name or title used in connection with any services rendered or Feature prepared or furnished under this agreement; to copyright any such Feature and to secure any renewal of copyright permitted by law; to communicate the Feature by radio broadcasting, rebroadcasting, wired radio, television, cable, telephone, satellite, or by any other methods or means (now or hereafter existing) of transmitting or delivering ideas, sounds, words, images, or pictures; and to vend and otherwise dispose of, and to otherwise exercise with reference to said Feature any and all rights and privileges now and [sic] in existence or which may hereafter accrue. As used in this Section 3(a), the term "Feature" includes any derivative work based on the Feature.

The grant of rights in this provision is very confusing, because it is unclear what "during the term of this agreement" is referring to. One interpretation is that the syndicate is allowed to hold the copyright and exercise it in any way during the course of the contract, although ownership reverts to the artist at the termination of the contract. The other interpretation is that the syndicate owns the rights to all of the work furnished to it under the syndicate contract. Thus, any articles or cartoons created for Universal during the contract would belong to Universal, but the artist would own anything created before or after the contract term. This ambiguity can be remedied by changing the first sentence as follows:

> 3) RIGHTS GRANTED SYNDICATE. (a) The Syndicate shall have, and the Producer hereby grants to the Syndicate for the duration of the agreement, a license to all copyright, proprietary, and exploitation rights whatsoever in the Feature produced for the Syndicate by the Producer during the term of this agreement, including but not limited to the following exclusive rights.

For most artists, ownership of the copyright to their work is the single most important part of the contract. Retention of the copyright by the artist is now common, whereas ten years ago it was very rare.

Artists must realize that this is a major concession by the syndicates. Not all syndicates offer copyright ownership in their boilerplate contracts. Further, syndicates that grant copyright ownership may prefer to hold it in their name during the contract term, subject to the agreement to return the copyright to the artist at the termination of the contract. As pointed out by Robert S. Reed, former President, Chairman, and CEO, Tribune Media Services, "During the contract period, it is easier and less expensive to let the syndicate take the copyrights and trademarks."

This is not a strong argument. Since works are automatically copyrighted upon being fixed in a tangible form, the copyright burden is nonexistent. Even copyright registration filings for enhanced protection are easy and cheap. Furthermore, a trademark filing is usually only a few thousand dollars including filing fees and attorney's fees. The real issue is the ownership of exclusive rights to exploit the feature during the term of the contract. The syndicate has these key rights, and ownership of the copyright in the syndicate's name is one more way for the syndicate to impress that fact upon artists. Otherwise, artists unfamiliar with copyright law might believe that holding the shell of the copyright somehow reserves rights that were signed away in the contract. For example, an artist who owns both the original art and the shell of the copyright might feel that he could republish that art.

As discussed in section 2, the artist should also attempt to carve out as much of the licensing and merchandising rights as possible. The two most common compromises are (a) to regain the rights after a period of five or so years if the syndicate isn't making good use of them by generating significant revenue, or (b) to leave the rights with the artist, but require that the artist pay over a portion of any net proceeds from the licensing and merchandising rights.

The next provision states that the syndicate may hire other companies to perform services the syndicate owes to the artist.

> The Syndicate may, at its option, appoint an agent or agents to exploit one or more of the rights so granted.

It is unclear how this provision differs from the delegation of duties and assignment of rights permitted under section 2. It is likely just a redundancy, which can be beneficial if it reinforces an unclear point.

Even when the syndicate has broad rights by contract, potential licensees often feel nervous about dealing with just the syndicate. Therefore, the syndicate inserts the following provision in order to insure the marketability of its rights.

> Whenever requested by the Syndicate, the Producer shall execute any instruments which in the judgment of the Syndicate may be necessary or desirable to secure to the Syndicate the rights granted by the agreement.

This is a reasonable provision. Potential licensees may request that the artist also be a party to the agreement, even if the syndicate claims to have full legal authority. This prudent risk management protects the licensee from becoming a party to any later fight between the syndicate and the artist. Moreover, it assures the licensee that its rights will survive a termination of the syndicate/artist contract.

However, artists should consider certain risks associated with this provision. Any grant by the syndicate to a third party of a license that exceeds its authority may become valid if the artist also signs it. An artist who expects substantial licensing may wish to insert a clause that indemnifies him in the event that the license exceeds the syndicate's authority. Such a provision might read:

> *Whenever requested by the Syndicate, the Producer shall execute any instruments which in the judgment of the Syndicate may be necessary or desirable to secure to the Syndicate the rights granted by the agreement. In the event that any such instruments grant rights in excess of those contemplated by this agreement, the Syndicate shall indemnify the Producer for any losses he may suffer.*

If the syndicate will not agree to this modification, the syndicate is essentially retaining an option to violate the agreement at will.

The next portion of the contract addresses the fact that publicizing the artist can be an important part of selling the feature. Scott Adams, for example, has been the subject of many newspaper articles. Such exposure generates excitement about the product and, in the case of comics features, may lure readers to the funnies pages in general. Several syndicates include a provision to facilitate such publicity.

> (b) The Syndicate, and its subscribers, agents and appointees, licensees, and successors shall have the right to use the Producer's name, picture (color and black-and-white, provided by the Producer), and biography for promotion, trade, and advertising purposes in connection with the rights granted the Syndicate hereunder.

Because of the potential importance of publicity to an artist's career, the artist may wish to ask for final approval rights over his biography.

A few artists dislike some or all aspects of publicity. If this is an issue, the artist ought to seek the deletion or modification of this provision. Syndicates are unlikely to be particularly stubborn on this minor point.

Section 4: Editing: Failure To Deliver

The right of the syndicate to edit or reject an artist's work occasionally flares into a source of significant tension. Syndicates head off many arguments by including an unambiguous editorial provision.

> 4) EDITING: FAILURE TO DELIVER. The Syndicate shall have the general editorial supervision of the Feature, but the Syndicate shall make no substantive changes to the Feature without the Producer's prior approval. If the Syndicate determines that a particular installment of the Feature is not suitable for publication, it shall return it to the Producer for revision and resubmission.

All syndicates require a similar provision. The provision is balanced in the sense that the syndicate is prevented from changing the comic, but is not under any obligation to run a work the syndicate cannot support.

Another reason for the provision is that if the syndicate releases an objectionable work, then the newspapers must choose between the unattractive options of running a questionable strip or omitting it for the day. Newspaper editors would rightly feel unfairly burdened by such problems and may be less inclined to purchase other features from a syndicate that cannot control quality or content. This would unfairly hurt the other artists in the syndicate.

Some artists are very possessive about their work and do not want anyone touching it. These individuals need to define what they consider "substantive" changes so that there is no misunderstanding with the syndicate.

The next section addresses deadlines. Many artists interviewed stated that deadlines are what motivate them. The following provision provides the penalty for missing a deadline.

> Upon the inability (whether due to disability, death, or otherwise) or the failure of the Producer to submit the Feature, suitable for publication, as determined by the Syndicate, within such time in advance of the date of publication as the Syndicate specifies pursuant to Section 1 or Section 12, the Syndicate shall have the right, in addition to any other rights and remedies hereunder: (a) in the case

of late submission, to subtract from the amounts payable to Producer under this agreement all costs and expenses occasioned by such late submission (including, without limitation, freight, mailing and handling, and overtime of personnel).

Not only is it fair to permit the syndicate to charge back additional costs, but also the artist benefits in that it increases his incentive to stay on schedule. On the other hand, there have been some horror stories, such as enormous overnight delivery bills of questionable necessity. The possibility of unfair charges can be tempered with a couple of extra provisions. First, since a portion of the syndicate's job is effective editing, a problem arising from a failure in the syndicate's editing process should be the syndicate's responsibility. Second, expedited delivery charges to a large number of newspapers could seriously hurt an artist financially, so such charges must be truly necessary. Many businesses routinely overuse such services, and there would certainly be a strong inclination to do so in the event of a late change that the syndicate was not paying for. Reasonable language might look as follows:

(a) in the case of late submission, to deduct as its sole remedy from the amounts payable to Producer under this agreement all costs and expenses occasioned by such late submission (including, without limitation, freight, mailing and handling, and overtime of personnel). Notwithstanding the foregoing, the Producer shall not be required to pay such costs if they are a result of the Syndicate's editorial oversight. Further, overnight delivery and other forms of expedited delivery are subject to a reasonableness limitation based on actual necessity and not mere convenience.

Other possibilities include a cap or some sharing arrangement for costs, but these are more a matter of individual preference or negotiating strength than of fairness or efficiency.

The following provision serves as the key contractual remedy available to a syndicate.

(b) in the case of nonsubmission, to have the Feature prepared by others, deducting the expenses incurred by it in this connection, including the compensation of a substitute writer or artist, from any amounts payable to the Producer under this agreement.

This provision is tremendously important to both the artist and the syndicate. The wording covers both the case in which the artist is unwilling to submit material and instances in which he is unable to

submit, such as disability or death. Many artists regard the preparation of their feature by syndicate "henchmen" as abhorrent for artistic reasons. The provision also seriously weakens an artist's potential threat to "go on strike." On the other hand, the syndicates have a strong fairness claim to the full benefit of the contract as compensation for their work in launching and supporting the feature. If an artist were unable or unwilling to produce after the first year, then the syndicate would lose both its financial investment in the publicity campaign and the missed opportunity of having launched a different feature.

Several middle range solutions could narrow the scope of disagreement. First, the artist might request the authority to select a substitute artist who would take over in the event of death or disability. This could be made subject to the syndicate's reasonable right of approval. In cases where the artist refuses to submit an installment, the syndicate would retain the right to select its own replacement artist. Second, the amounts paid to another artist should be limited to revenue generated by the actual substitute installments. Thus, if the syndicate owes the artist for the previous month's installments or licensing revenue, the syndicate should not be allowed to offset against that income. Future income should likewise be protected after the artist resumes production. A provision including these changes might look as follows:

> (b) in the case of voluntary nonsubmission, to have the Feature prepared by others chosen by the Syndicate, deducting the expenses incurred by it in this connection, including the compensation of a substitute writer or artist, from amounts payable to the Producer for the substitute installments. In the case of involuntary nonsubmission for such reasons as death or disability, to have the Feature prepared by a substitute artist or writer of the Producer's selection subject to the Syndicate's right of approval, which shall not be unreasonably withheld. The Syndicate may deduct the expenses incurred by it in this connection, including the compensation of the Producer-selected substitute writer or artist, from amounts payable to the Producer for the substitute installments. If the Producer is unable or unwilling to select a substitute artist or writer, the Syndicate may make the selection.

The above phrasing permits the continuance of the feature after the death or permanent disability of the artist. Syndicates obviously prefer this. So, too, an artist may want his family to receive the income that results from continued production.

On the other hand, many artists abhor the thought of their feature continuing after their death or disability. Some syndicates' boilerplate contracts do not require continued production, and other syndicates are willing to negotiate. A provision reserving more rights to the artist might look as follows:

> In the event of the Producer's death or permanent disability, the Syndicate may continue to release those unpublished installments of the Feature then in existence. The Syndicate may not employ substitute artists or writers to continue production of the Feature without the consent of the Producer, his estate, or his representative. If the Producer, his estate, or his representatives do elect to continue the Feature, it must be with the Syndicate and pursuant to the terms of this agreement.

The last sentence insures that the death or disability does not become an opportunity to escape the contract with the syndicate or to demand renegotiation.

Artists who definitely wish their strip to end at their death face yet another problem. If the artist owns the copyright to the strip, then such rights automatically flow into the estate. Because it is property, the copyright may be sold to satisfy the artist's debts or by relatives who are more interested in the profit than the deceased's desire to see the feature end for artistic reasons. Any attempt through the syndication contract to restrict the artist's heirs or creditors from selling the rights to a syndicate or merchandiser would be awkward and possibly unenforceable. An estate planning attorney or corporate attorney may be able to devise a trust, corporation, or other suitable vehicle that would insure that the feature ends at the artist's death.

Section 5: Producer's Warranties and Indemnification

The following requirement that the artist warrant originality and noninfringement of others' rights is one of the most surprising provisions to new artists, but it is absolutely standard and relatively fair.

> 5) PRODUCER'S WARRANTIES AND INDEMNIFICATION. The Producer represents, warrants, and agrees, to and with the Syndicate and its assignees and agents, that (except to the extent attributable to editing by the Syndicate which was not approved by the Producer) all material furnished pursuant to this agreement will be original with him and that the use of such material as contemplated by this agreement will not constitute libel or conflict with or infringe upon any copyright, right of privacy, or other rights of any third person or firm.

Contracts from other syndicates often list the "other rights," such as: unfair competition, trademark, trade name, conflicting contract obligations, plagiarism, and literary piracy. According to one artist, "All of the syndicates are unwilling to negotiate on this issue. In practice, the syndicate is the deep pocket, so they are responsible anyway. What is outrageous is that the syndicate can edit a cartoonist's work and then claim not to take responsibility for their own changes." A syndicate not taking responsibility for its own changes certainly would be unfair. Universal and most of the other syndicates accept responsibility in their boilerplate for their own unapproved changes.

Also, despite the fact that the syndicates are the "deep pockets," the indemnification provision makes sense. Syndicates and artists alike should fear the possibility of lawsuits, given the many theories of liability mentioned above. By keeping the artist responsible, at least on paper, the syndicate encourages the artist to take great care to prevent claims. In the event of a claim, the artist's interests are more closely aligned with those of the syndicate. Finally, if the artist is uncooperative, then the provision provides the syndicate with extra leverage.

The next part of the provision merely states that the effect of the warranties is that the Producer must indemnify the syndicate.

> The Producer will indemnify the Syndicate (and any sales, syndication, publication, or other agency or firm to which the Syndicate has delegated rights under this agreement) against any expenses or damages (including reasonable attorneys' fees) resulting from any breach or alleged breach of such representation and warranty.

The problem is that the "expenses and damages" provision needs greater precision in its definition. Payments to the claimant are obviously covered, as are attorneys' fees. Presumably, court costs are also included. Other issues are not so clear. How are the time and expenses of syndicate personnel to be handled? Is the artist responsible for damage to the syndicate's business? Even if the syndicate would not pursue the artist for such less-than-obvious costs, the current wording permits the syndicate's delegates who are damaged to do so. An additional sentence taking care of these problems might look as follows:

> *The Producer will indemnify the Syndicate (and any sales, syndication, publication, or other agency or firm to which the Syndicate has delegated rights under this agreement) against any expenses or damages (including reasonable attorneys' fees) resulting*

> *from any breach or alleged breach of such representation and war-*
> *ranty. Provided, nevertheless, that the Producer shall be responsible*
> *neither for consequential damages incurred by the Syndicate or any*
> *other indemnified party nor for the time of personnel employed by*
> *the Syndicate or other such indemnified party.*

This language strikes an appropriate balance between the syndicate's reasonable need for indemnification and the artist's need to prevent the syndicate from overreaching.

The next section of the indemnity provision can be seen justifiably as either outrageous (by the artists) or perfectly reasonable (by the syndicates). The provision provides the syndicate with total control of all disputes.

> *The Syndicate and any such indemnified party shall have the right,*
> *at their discretion, either to defend any claim or suit by counsel of*
> *their choice or to settle the same on such terms as they deem*
> *advisable.*

Since almost all civil liability cases are settled out of court, if the indemnity provision did not include settlement, then the syndicate would face the unattractive choice of taking the case to court or settling and paying the loss itself. Taking a case to court might well be uneconomical after attorneys' fees, and it could expose the syndicate to the risk of a large award, including punitive damages, that exceeds the artist's ability to indemnify.

On the other hand, it seems unwise for the artist to hand over a "blank check" to a syndicate, permitting it to settle on whatever terms it likes. It creates a very odd set of incentives encouraging settlement, especially for smaller cases in which the syndicate believes that the artist could actually afford to pay. Lawsuits are inherently uncomfortable and distracting to senior management, so why would the syndicate fight a plausible $5,000 claim if the artist can pay it? At least one syndicate routinely accommodates the artist's concerns by omitting the settlement language. A reasonable provision here might look as follows:

> *The Syndicate and any such indemnified party shall have the right*
> *to defend any claim or suit by counsel of their choice but shall not*
> *be entitled to indemnification payments from the Producer for a*
> *settlement unless the Producer agrees to the settlement in writing.*

Artists are likely to be frightened of litigation, so this provision merely protects them from overreaching by the syndicate and permits the artist the right to fight if he feels strongly and can afford it.

Another unusual part of the broader indemnity provision is the following one-half reimbursement clause for a successful defense.

> In the event that a final judgment dismissing any such claim or suit without liability to the Syndicate or any such indemnified party, the obligation of the Producer shall be limited to reimbursing the Syndicate and such indemnified party for one-half of all expenses incurred by them in connection therewith.

The one-half indemnity for a successful defense in court is subject to several interpretations. It looks like a generous offer by Universal (an offer not matched by many syndicates) to share costs in the normal 50/50 fashion that revenue is shared. It also makes sense to wait until final judgment before the syndicate agrees to a limited indemnity. Under this logic, however, it is unclear why the language appears to exclude instances where the adverse party abandons the claim. This may be an unintentional oversight. To correct it, the artist might use language such as:

> In the event of (a) a final judgment dismissing any such claim or suit without liability to the Syndicate or any such indemnified party, or (b) the claimant withdraws the action prior to adjudication, then the obligation of the Producer shall be limited to reimbursing the Syndicate and such indemnified party for one-half of all expenses incurred by them in connection therewith.

Another downside to all of the above options is that they leave the artist solely responsible for the Syndicate's expenses in the event that a court finds some small liability, but clears the artist of most claims. Only an absolute victory triggers the reduced indemnity. It might be possible to cap expenses at some negotiated figure, such as twice the award, but this is an issue of low importance and likely to not be worth wasting time or bargaining leverage over, unless there is reason to believe that an harassment suit is likely.

Many of the syndicates also require a separate representation that the artist has authority to enter into the contract and has no related contractual obligations to others. This is substantially the same issue as in the above warranty. Artists who are switching syndicates need to be careful here, because many of the provisions that allow early release from a contract also grant the syndicate some form of option. For example, if the artist has exercised his termination option due to the failure of the strip to reach a certain gross revenue figure, syndicates usually have the right to make up the difference between the hurdle rate and the actual amount of receipts.

The wording of the contract often does not restrict the syndicate from exercising the option at any time until the contract terminates.

Occasionally a syndicate's contract mentions the artist's responsibility as a journalist. It makes sense that a syndicate would be concerned that the artist might use his strip or column as a platform to communicate with millions of people about inappropriate personal beliefs. On the other hand, artists' experiences and beliefs are often woven into their feature in legitimate ways that add to or personalize the feature. Reasonable language accommodating both syndicate and artist concerns might look as follows:

> *The Producer acknowledges that he is a member of the journalistic profession and shall be governed by its ethical standards. The Producer shall bring to the attention of the Syndicate any actual or potential conflict of interest between the subject matter of the Feature and the Producer's personal dealings, including social, religious, financial, professional, and other issues.*

This language does not threaten the wide latitude granted to artists, but the artist also may not insert a product placement for Burger King without syndicate approval. This provision also protects the artist in the sense that readers often complain to newspapers when artists bring personal biases into their comics or columns. Since newspaper editors hate complaints, an artist risks moving up in the potential "drop list" if the editor can reduce complaints by dropping the feature.

Critics of lawyers might assert that adding the above provision is overkill in light of the fact that the syndicate is allowed under section 4 to refuse to syndicate installments of the feature. Further, self-preservation would logically seem enough incentive for artists to self-edit their material of all subjects likely to annoy readers or newspaper editors. In reality, the issue does arise: Johnny Hart of "B.C." reportedly has a specific exception to this provision, which allows him to express his strong religious views. Most artists do not have his negotiating power, and so for the majority of artists, the provision serves two useful purposes. First, the provision helps to educate and sensitize the artist to possible conflicts of interest. Conflicts of interest are often surprisingly complicated and not mere "common sense." If the provision simply prompts some artists to ask the syndicates questions about what is appropriate material, the provision has served its purpose. Second, the provision settles in advance many potential disputes over questionable material. Artists may understand the conflicts of interest issue, but disagree with the syn-

dicate on a particular installment of the feature. Contract disputes are best resolved with specific language covering the issue—the more general the provision relied upon by one party, the more likely the other side is to see room for argument or be taken by surprise. Here, resolving a specific conflict-of-interest dispute under the general editorial supervision clause in section 4 of the Universal contract seems heavy-handed. Undoubtedly, this provision is irrelevant to many artists. Just as certain, however, is that it will serve one or more of the useful functions described above for some portion of each syndicates' portfolio, because artists vary in temperament and in knowledge of legal and business issues.

As the artist quoted above mentioned, the syndicates have the "deep pockets" and will probably be held liable if anything goes seriously wrong. Short of a serious problem, however, the above provisions provide effective management tools.

Section 6: Exclusivity; Rights of First Refusal

Syndicates include the following provision in order to make sure that they have control over both the feature and the artist.

> 6) EXCLUSIVITY; RIGHTS OF FIRST REFUSAL. During the term of this agreement, the Producer will not, without the prior written consent of the Syndicate, produce or consent to be produced (under his name or any other name or names), or advise or assist in any way with the production of, any material of similar name or appearance to the Feature for publication in any newspaper, periodical, book, or other publication. The Syndicate shall have the option to meet any bona fide offer for the services of the Producer with respect to material suitable for syndication during the term of this agreement, provided, however, that such option shall be exercised by the Syndicate within 90 days after receipt of written notice of such a bona fide offer.

This provision, which is common to all syndication contracts, has three important effects. First, it provides the syndicate with exclusivity on anything the artist does related to the feature. Second, the artist grants the syndicate a right of first refusal on other syndication concepts. Third, by negative inference, the artist remains completely free to pursue nonsyndication ideas that are not related to the feature. However, it is far from clear that the provision covers all of the important subissues or strikes a fair balance of interests between the parties. Each issue deserves further study.

The heart of the exclusivity provision reads as follows:

> During the term of this agreement, the Producer will not, without
> the prior written consent of the Syndicate, produce or consent to be
> produced (under his name or any other name or names), or advise or
> assist in any way with the production of, any material of similar name
> or appearance to the Feature for publication in any newspaper,
> periodical, book, or other publication.

Syndicates feel that they are partners with their artists in creating
the value of the feature. This belief leads to four reasons for this pro-
vision. First, syndicates feel entitled to share in the revenue gener-
ated by the feature whether directly or indirectly. Second, syndicates
wish to prevent the artist from somehow damaging the feature.
Third, an additional similar feature could "cannibalize" the first fea-
ture because of the limited amount of space in newspapers. Such an
effect could occur, because at least some newspapers will only take
one of the strips. Fourth, the artist's good ideas would be spread
among two strips. For example, all of the above four issues would
arise if Scott Adams were allowed to spin off from "Dilbert" a second
strip named, say, "Cubicle Man."

The main problem with the provision's "similar name or appear-
ance" language is that the "similarity" requirement defies objective
definition. Any attempt to articulate standards defining "similar" are
likely to be clumsy and imperfect. Consequently, the provision
should probably be left unchanged, since it already provides enough
guidance so that a wise artist can avoid problems by simply staying
outside of the gray area. Other syndicates use the language "similar
subject," in which case the artist should define the subject with
greater particularity, such as "similar subject, namely a comic strip
about AN office worker" or "AN advice column." Note how the language
performs a guiding function that helps both parties by steering them
away from conflict; the provision preserves the relationship, and nei-
ther party wastes time nor money in fighting.

In contrast to the first half of section 6, which merely serves to
protect the syndicate's interest in the existing feature, the second
half extends the syndicate's claim to a right of first refusal on the
artist's other syndication ideas.

> The Syndicate shall have the option to meet any bona fide offer
> for the services of the Producer with respect to material suitable for
> syndication during the term of this agreement, provided, however,
> that such option shall be exercised by the Syndicate within 90 days
> after receipt of written notice of such a bona fide offer.

There are five possible explanations why a syndicate should care about the artist's other projects. First, syndicates want to have the first opportunity on great ideas or great artists. After investing time and money, as well as foregoing the possibility of promoting other artists, a syndicate feels entitled to an option on the artist's other concepts if the artist becomes a star. Second, syndicates are very image conscious; losing an artist's new idea is often seen as a vote of no confidence in the syndicate by the artist. Third, there are possible economies in publicity and administration to keeping artists under one roof. Fourth, the syndicates face no significant downside to getting the option, so the provision might as well be included. Fifth, the syndicate may wish to discourage a second strip. A key concern among the syndicates of an artist launching a second syndicated strip is that the artist may not have enough time to do both to the best of his ability.

Artists can respond that the syndicate already has editing power under section 4 and an explicit promise to maintain quality under section 1. Further, artists argue that restricting an artist from other work in such an artificial manner and without covering all of the other ways in which an artist can overburden himself is both ineffective and unfair. These five reasons explain the syndicates' interest in obtaining a right of first refusal, and at least some of the reasons are good ones.

Because rights of first refusal are so standard, artists with limited bargaining power should focus on insuring that the rights granted do not exceed what the syndicates need for valid reasons and on eliminating the syndicates' ability to abuse the provision. In particular, the right of first refusal acts as a time barrier and may discourage other syndicates from pursuing the opportunity if they believe that it will be taken from them. Thus, artists need to reduce the ninety-day decision period. Syndicates argue that purchasing a new feature is a major decision. They assert that a long response time is needed so that they may research the proposal and filter it through the decision-making process. On the other hand, there are good reasons why syndicates can probably respond very quickly to any proposal that is so good that the syndicate would legitimately care about having a right of first refusal on it. In particular, this provision is more to insure that the syndicate keeps its few superstars than it is about keeping the average artist in the syndicate's lineup. Any artist's new proposal, plus his past work for the syndicate, should provide the syndicate with vastly more information than it normally has when signing a new artist. Combining these facts with the real-

ity that syndicates are experts at analyzing proposals, the initial review should take a few days at most. Then add a few weeks for market research and the formal decision-making process. Overall, twenty days squeezes the syndicate whereas thirty days is generous.

Section 7: Payment to Producer

The Payment to Producer provision is crucial and contains many hidden deductions that reduce the ultimate payment to the artist.

> 7) PAYMENT TO PRODUCER. (a) In consideration of the satisfactory performance by the Producer of his obligation under this agreement, the Syndicate shall pay to the Producer, not later than the twentieth day of each month.

This introductory part of the provision contains two issues: payment date and condition of payment. The syndication industry works on a payment schedule of approximately twenty days after the close of the month. This is reasonable. The condition of payment upon "satisfactory performance," however, raises the possibility of undue leverage over the artist. Under this clause, the syndicate could withhold all or a portion of payments in the event of a dispute. Thus, the syndicate seems to create a powerful and free remedy for any possible breach by the artist of any contract provision. The artist, in contrast, for this and all other disputes can only seek redress from a court. Other syndicates rarely include a "satisfactory performance" provision. A fairer drafting might look as follows:

> 7) PAYMENT TO PRODUCER. (a) The Syndicate shall pay to the Producer, not later than the twentieth day of each month.

This revised language puts the syndicate and artist on more equal footing with regard to remedies for a breach of the contract.

The following provisions detail the split of revenue and sharing of costs with the syndicate. This is the most heavily revised section of the contract; the suggested revisions to the language are given at the end of the discussion.

> (i) with respect to the sale for newspaper publication within the continental United States of the rights to the use of the Feature, 50 percent of the net domestic newspaper collections during the preceding month (derived by deducting from the gross collections from such sales the Syndicate's cost for in-paper promotion, sales and promotional kits, sales and commissions [not in excess of 2 percent], production, transportation by wire or other mechanical or electronic means, securing and protecting trademark and copyright in connection therewith).

The standard split for new artists is 50 percent of the net revenue, although a few syndicates may offer 50 percent of the gross revenue (or something close to gross revenue). Obviously, a share of gross revenue is far more favorable to the artist, both financially and in terms of monitoring. The expense deductions in Universal's contract cover the same issues typically found in other syndicates' contracts. The main difference is that other syndicates' contracts sometimes use a more detailed list. For example, "production" in the Universal contract is a general catchall, while other syndicates list the costs, such as mats, proof sheets, camera work, digitalization, reproduction, engraving, and cuts. A detailed list is better, because it prevents misunderstanding as to what expense charges are legitimate. When the language merely lists "production costs," no standard exists for determining what constitutes a production cost. Moreover, whether listed generally or specifically, there is no agreement on how much, if any, overhead should be allocated to the easily traceable costs.

Artists cite two main sources of concern. First, syndicates generally have poor information and tracking systems. As a result, many are not able to substantiate what work is done or why a particular amount is charged. Second, syndicates try to defray overhead costs through expense reimbursements. As one artist put it, "Accounting is the syndicate's responsibility. Unless we have our own accountant at the syndicate, there are all kinds of ways we can lose money. For instance, the cost of camera work and proof sheets, which I believe are billed at a profit to the syndicate over and above their traditional 50 percent. They are always looking to make an extra buck. A syndicate is like a record label, it charges for everything."

Some syndicates offer a cap on production expenses, and some artists negotiate for it if the syndicates do not offer. Most expense caps are fixed dollar limits. The usual cap on production costs for comics appears to run between $110 and $200 per week for the six daily installments. Further, syndicates generally hire specialists to produce the Sunday comics installment. This is a separate reimbursable expense of approximately $450 per month. A percentage cap makes sense from the artist's viewpoint as a way to insure a living wage, but few syndicates are likely to grant it, because the result is almost a "guaranteed minimum." If the artist is not earning enough to carry his costs on an ongoing basis and to compensate for his time, then the strip probably should not survive in the syndicate's view and in no way should be subsidized.

The expense deduction for *"in-paper promotion plus sales and promotional kits"* needs more explicit definition. In particular, there

is a question as to whether the costs are limited to direct costs or include a charge for the syndicate's services, such as the time of employees. The promotional kits for comics and columns are fairly standard: Typically, syndicates will do a four-color, heavy-stock folder, 9″ × 12″ with two pockets for holding sample release sheets and the salesman's card. They may do the art themselves or ask the artist for help, if the artist is likely to make a helpful contribution. These are mailers or leave-behinds.

Getting this material right and printing in high volumes costs several thousand dollars. The contract should, therefore, state who will perform the services and what is reimbursable. A common format is for the syndicate to receive reimbursement for the cost of printing and transmission, but not for overhead or salaries.

Another major issue is the timing of any of these expenses. Typically the major promotional push occurs at the launch of a feature. As a result, a fledgling artist who earns very little can have a several-thousand-dollar obligation to his syndicate. Some limitation is needed on the timing of the syndicate's collection of this money, as well as a provision for forgiveness of the obligation in the event that the feature is discontinued. Artists may be tempted to limit the total amount reimbursable, but this reduces the syndicate's incentive to promote the feature. Since it actually costs the syndicate considerable overhead and personnel expense to create and distribute the promotional material, the artist who pays one dollar for materials and mailing costs actually receives much more than one dollar of services. Dollar limits to expenses should, therefore, only reflect the artist's need to generate sufficient and regular income to maintain a reasonable lifestyle during the building of his client list. A limit of $300 per month seems reasonable, subject to a cap of 10 percent of the artist's share of gross collections. This may be insufficient to fully reimburse the syndicate during heavy promotional years, but it should reduce the balance to zero quickly in future years if the strip survives.

A limit on promotional expenses differs fundamentally from the limit on production expenses, because promotional expenses are very large, can be classified as a capital investment, and occur only at the launch of the feature. All of these reasons suggest that a payment-plan form of reimbursement is fair, effective, and will result in full repayment. The production expenses, on the other hand, are small and ongoing and serve little investment purpose.

Several artists mentioned that the syndicates provide the artists with very poor expense tracking. Some artists claimed that

the syndicates are deliberately vague about costs, so as to obscure the inclusion of personnel salaries and overhead. Others suggested that the syndicates merely fail to keep good records, even for themselves. On the other hand, a few interviewees contended that the syndicates sometimes do not charge the artists for certain allowable expenses, because it is not worth the effort. Regardless of which is true in a particular instance, artists are entitled to know exactly how much they are being charged and for what. Further, an increasing number of artists are able to provide certain production services with their computer equipment, often at a saving. To the extent that the artist provides his feature to the syndicate in a more advanced state of production, he should be contractually entitled to a reduction in the expenses charged to him. Some syndicates already accept this simple and fair proposition on an artist-by-artist basis; others do not. An issue such as expenses rubs against syndicates' historical resistance to any attempt to pry into their financial status. Also, creating a price list and keeping records on an artist-by-artist basis may entail additional work by the syndicate. However, any syndicate which is unable to track its expenses sufficiently to create a price list for artists is out of sync with modern business practices and should be intensely interested in enhancing its information system. If the syndicate resists modern business practices, that is probably a bad sign for the services the artist can expect over the course of a long contract.

The provision granting the syndicate reimbursement for *"securing and protecting trademark and copyright"* is minor, since both copyright protection and trademark status are easy and inexpensive to achieve. A minor issue such as this is probably best decided on pure fairness grounds in order to prevent resentment over an immaterial item. In cases where the artist owns the copyright or is entitled to its return, he is the ultimately benefited party, so it appears fair that he should pay for the expenses of establishing and protecting the copyright. Where the syndicate has true ownership of the copyright, making the artist pay for protecting it seems unjustifiable. A few syndicates do not require any reimbursement for such expenses, since the total amount is so small.

A much greater issue regarding the *"protecting"* of copyrights and trademarks is whether this means that the artist must pay litigation costs incurred by the syndicate in pursuing infringement claims. Since several appellate-level cases have occurred concerning such claims, this type of litigation is a very real possibility. Several syndicates have provisions that expressly provide for reimburse-

ment. The specific terms of reimbursement, however, differ among syndicates. These differences give rise to a number of important considerations in drafting the recovery provision.

First, what control does the artist have over the syndicate's expenditures? Syndicates almost always want free reign to decide how they should pursue the litigation.

Second, how are costs allocated in the event that the syndicate enforces the work of multiple artists in a joint action? Do the artists pay by their proportionate share of the value protected or by the number of violations? What about the case where the syndicate brings several claims, but not all of the artists benefit from each claim? What if the syndicate wins based on the claims of some artists, but not others? Must the winning artists subsidize the losing artists?

Third, may an artist decide not to pursue a claim or to drop it partway through? It seems fair that the person paying the bill should have the right to decide whether to pursue the litigation.

Fourth, does the individual artist have different interests than the syndicate? The syndicate may want to develop a reputation as a tough enforcer of its rights, whereas the artist may want to maximize his return or minimize his effort on this case alone. For example, Disney spent many years building a reputation as an all-out litigator on behalf of its character properties. Now, potential infringers know that Disney will fight far beyond the value of the dispute. This means that people contemplating infringing on Disney's rights are dissuaded, which in the long run means that Disney has fewer cases to fight and more people deciding to license characters rather than risk infringing. Syndicates do not have the luxury of creating such a reputation, because even though it might benefit the average artist, it would be an unfair burden to the artists who pay for its development.

A middle-range resolution, which also appears the fairest overall allocation of rights and responsibilities, is for the syndicate to bear all litigation costs, subject to reimbursement out of any recovery or settlement. Under this formula, the artist should permit the syndicate reasonable discretion over when and how to pursue claims and over the allocation of costs and compensation in any joint recovery. This solution does not eliminate the problems with allocating awards among artists, but it is more fair to give the syndicate discretion when the syndicate bears responsibility for the costs of failed litigation.

Under both the current Universal boilerplate and the revised formula, cases may occur where either the syndicate or the artist exercises discretion not to pursue the litigation. If so, the other party

should be permitted to pursue the litigation at its own expense and retain all settlements or judgment damages. This power encourages the protection of artist rights in as many situations as possible, which will in the long run discourage infringement.

Combining all of the above comments, an equitable version of the provision might look as follows:

> (i) with respect to the sale for newspaper publication within the continental United States of the rights to the use of the Feature, 50 percent of the net domestic newspaper collections during the preceding month. Net domestic newspaper collections shall be derived by deducting from the gross collections of such sales the Syndicate's cost for:
>
> (A) production expenses, subject to a monthly limit of $___ for daily features and the actual cost of third party preparation of Sunday features. Production expenses shall be limited to mats, proofs, film negatives, digitalization, reproduction, engraving, and cuts. The Syndicate shall provide an itemized list of such expenses together with each remittance. The Producer may chose to provide such services in the future, and in return the Syndicate shall not charge the Producer for those services. In recognition of the Syndicate's administrative needs, the Producer must provide such services for the entire month that the Producer wishes to receive credit, and the Syndicate shall be entitled to reject such services if they are materially inferior to those supplied by the Syndicate or its agents.
>
> (B) the direct costs of in-paper promotion solely for the benefit of the Feature and not for the benefit of the Syndicate in general or any of its other text or comic products. Direct costs shall include the costs of materials, printing or reproduction, and distribution by mailings or electronic means. Such direct costs shall not include design work, overhead, salaries, or any other indirect cost of the Syndicate. These costs, together with those of subsection C, shall not exceed the lesser of $300 per month or 10 percent of gross collections.
>
> (C) the direct costs of sales and promotional kits solely for the benefit of the Feature and not for the benefit of the Syndicate in general or any of its other text or comic products. Direct costs shall include the costs of materials, printing or reproduction, and distribution by mailings or electronic means. Such direct costs shall not include design work, overhead, salaries, or any other indirect cost of the Syndicate. These costs, together with those of subsection B, shall not exceed the lesser of $300 per month or 10 percent of gross collections.

(D) sales commissions [not in excess of 2 percent].

(E) transportation by wire or other mechanical or electronic means.

(F) securing and maintaining the trademark, copyright, other literary property, and any other rights covered by this agreement in connection with the Feature and its title. Such expenses shall not cover the costs of enforcing these rights against third parties, as such costs are provided for under (a)(v) of this Section.

The last subsection, (a)(i)(F), removes reimbursement of litigation costs from the category of expenses deductible from the monthly payments due to the artist. For two reasons, this is the artist's preferred option for reimbursing the syndicate. First, the option means that the huge expenses of litigation are not directly removed from his paycheck. This insures a steady cash flow. Second, the option makes payment contingent on winning the case. The expenses would, therefore, arise only if there were a corresponding damage award to pay for them. Several syndicates may already have policies for expense reimbursements similar to the requirements of this revised provision, without being contractually required to be so generous. If so, then they should not be concerned about an artist's request to put it in writing. If not, the artist should raise the issue.

The following alternative to (a)(i)(F) leaves litigation cost reimbursement within the category of expenses deductible from the monthly payments due to the artist. The syndicate prefers this, because it may deduct the legal expenses automatically and thereby insure timely collection of the reimbursement. However, this exposes the artist to cash flow problems and reduces his leverage in the event of a dispute over the bill. Also, the artist pays whether or not he wins the case.

(F) securing and maintaining the trademark, copyright, other literary property, and any other rights covered by this agreement in connection with the Feature and its title. Further, Syndicate shall be entitled to reimbursement for the costs of legal action (including attorney's fees) in which the Syndicate asserts against a third party any of the rights granted to the Syndicate in this agreement, provided that the Producer authorizes such action and has not withdrawn such authorization. In the event that either the Syndicate or the Producer declines to pursue an enforcement against a third party, the other party shall remain free to pursue such enforcement at its own expense and shall be entitled to retain all settlement payments or judgment damages.

(Note that this alternative version of (a)(i)(F) covers a greater number of issues. This is merely for ease of structure; the same issues are addressed later in the contract, for those who choose to use the first (a)(i)(F) option.)

The next provision in Universal's contract differs from the first of this section only in that it covers foreign sales and the related special expenses. All syndicate contracts have some version of such a provision.

> (ii) with respect to the sale for newspaper publication outside the continental United States of the rights to the use of the Feature, 50 percent of the net foreign newspaper collections during the preceding month (derived by deducting from the gross collections from such sale the Syndicate's costs for agent's fees and commissions, in-paper promotion, production, trademark, copyright, and all other expenses and payments in connection therewith).

The key differences from (a)(i) are the additions of an unlimited *"agent's fees and commissions"* and a catchall provision of *"all other expenses and payments in connection therewith."* Other syndicates typically offer a more detailed clause and frame the charges as additional expenses, rather than as a separate provision. The generality of the Universal provision works against the artist, because the syndicate receives the power to make unlimited charges, many of which are very difficult to review. Furthermore, the long revisions to (a)(i) suggested by this review mean that (a)(ii) would now read better as a list of additional expenses.

Fortunately, the additional costs associated with foreign sales are easily specified. The main additional expense is the cost of foreign sales commissions. Syndicates usually cap these expenses somewhere in the range of 25 to 50 percent of gross collections. Other expenses unique to foreign sales may include costs of translation, currency conversion, agents' fees, and foreign sales taxes. A provision covering such differences might look as follows:

> *(ii) with respect to the sale for newspaper publication outside the continental United States of the rights to the use of the Feature, 50 percent of the net foreign newspaper collections during the preceding month. Net foreign newspaper collections shall be derived by deducting from the gross foreign collections of such sales the Syndicate's costs as provided for in Section 7(a)(i)(A-F), subject to the following adjustments:*
>
> *(A) Sales commissions paid to foreign agents shall be limited to 50 percent of collections directly attributable to such foreign agents.*

(B) The Syndicate may deduct the additional costs attributable principally to doing business outside of the continental United States, including but not limited to costs of translation, currency conversion, agents' fees, and foreign sales taxes.

These revisions are more of a clarification of the additional foreign expenses than a limitation of them.

The next provision relates to a specialty business and is of no material consequence.

(iii) with respect to the sale of pamphlet compilations of the Feature by advertisements in the syndicated newspaper version of the Feature, 15 percent of the retail list price of each such pamphlet sold.

Other syndicate contracts do not even address the pamphlet sales issue separately.

The range of sales and licensing opportunities outside of syndication and pamphlet sales means that the syndicate has a difficult time predicting the expenses associated with generating such income. The following provision provides broad leeway to the syndicate:

(iv) with respect to the sale of any other rights to use, in any media or form other than newspaper publication or pamphlet sale of the Feature, or of its drawings (or text), continuity, ideas, format, plots, themes, characters, or characterizations, 50 percent of the net collections (derived by deducting from the gross collections from such sales all of the Syndicate's expenses [including without limitation agency fees and commissions] in connection therewith).

Although granting such unrestricted authority to deduct expenses often troubles artists, it is probably necessary and less damaging than equal discretion elsewhere. Here, most of the expenses are to third parties, unlike syndication expenses, where the syndicate was often reimbursing itself and could include overhead. Thus, the syndicates really do receive half of any cost savings, and there are no benefits to higher costs. Also, inclusion of restrictions on the recovery of costs would reduce the syndicates' interest in pursuing outside opportunities. This would be counterproductive, given that artists interviewed for this paper almost universally condemned the syndicates' poor licensing record for nonblockbuster comics. The last thing the artist needs is for the syndicate to lose incentive. The following provision is the part of the cost reimbursement for legal expenses that was removed from sections 7(a)(i) and 7(a)(ii) under the preferred option for reimbursing the syndicate for legal

expenses. This section was moved here, because it is now a deduction from any settlement or recovery rather than from the artist's regular income stream.

> *(v) The Syndicate shall bear all litigation and other enforcement costs associated with protection of rights granted to the Syndicate under this agreement. The artist grants the Syndicate absolute discretion over when and how to pursue such claims. Should the enforcement result in a settlement payment or a damage award, the Syndicate shall be entitled to deduct from such payment all out-of-pocket costs associated with achieving such payment. The Producer shall be entitled to 50 percent of any portion of the payment remaining after reimbursement of the Syndicate's out-of-pocket costs. The Syndicate shall have reasonable discretion over the allocation of out-of-pocket costs, compensation, and punitive damages in any joint recovery among the Producer and other claimants. In the event that the Syndicate declines to pursue an enforcement against a third party, the Producer may pursue such enforcement at its own expense and shall be entitled to retain all settlement payments or judgment damages.*

The result of the provision is to enhance artist control over the amount and timing of enforcement costs.

Section 7(b) covers the syndicate's reporting responsibilities and the artist's auditing right.

> (b) The Syndicate shall render to the Producer monthly itemized statements (with remittances) of the income and disbursements of the preceding calendar month with regard to the Feature; and the Syndicate's records relating to the Feature shall be available to the Producer or his authorized Certified Public Accountants for inspection at all reasonable times during business hours.

The access to information granted here is a bare minimum. The artist should also wish to see an updated list of clients and the weekly or monthly pay rates for each. Further, there should be some notation of changes from the prior monthly period, such as new clients and cancellations. The syndicate's willingness to provide a list of clients may depend on whether the artist's strip is sold individually or as part of a package. Usually, syndicates prefer not to give a client list for sales as part of a package. One reason mentioned by artists is that the syndicates fear that the artists will attempt to sell the feature individually to those papers after the current contract expires. Other interviewees suggested that tracking individual paper use of

each feature would cause administrative problems, and the syndicate itself may not know which papers are actually running the feature regularly. A third area of sensitivity is that the syndicates sometimes report sales on all strips and columns included in a package, even if the papers do not run them. It is unclear from the available information which is the predominant reason or whether the syndicates would be willing to negotiate on this point.

The inspection right needs revision for the benefit of both parties. First, in light of the fact that financial books are not always current, the syndicate should require some advance notice of an artist's exercise of the inspection right. Second, as some syndicates already provide, there should be a restriction on the frequency of such inspections, so as to prevent their use as a nuisance. Third, the artist should seek greater flexibility in terms of who may carry out the inspection. Syndicates dislike giving outsiders access to financial information and, therefore, wish to restrict the review to the artist or his Certified Public Accountant. CPA review has the advantages of competent work with fewer disturbances of syndicate personnel, as well as of insuring adherence to ethical standards, such as confidentiality. The artist, on the other hand, may have reasons to prefer that his financial advisor, attorney, agent, or one of their employees conduct the review. Fourth, because proving errors can be expensive, the artist should also receive reimbursement for the related costs in the event that the syndicate made material mistakes. This remedy provides the syndicate with an incentive to insure accurate accounting and reduces the disincentive for the artist to monitor in the event that he feels something is wrong.

> *(b) The Syndicate shall render to the Producer monthly itemized statements (with remittances) of the income and disbursements of the preceding calendar month with regard to the Feature. Such statements shall include a list of current newspaper and other clients, as well as their scheduled pay rates and the amounts actually received. New clients and cancellations recorded during that month shall be conspicuously noted. The Syndicate's records relating to the Feature shall be available to the Producer, his attorney, his Certified Public Accountants, agent, or other personal representative for inspection during business hours twice annually with 5 business days notice. If such review determines that either the expenses or gross collections are misrepresented by 5 percent or more under Generally Accepted Accounting Principles, then the Syndicate shall pay the direct cost of such review and any other related expenses, including attorney's fees.*

This provision insures that the artist has access to basic information that many artists currently do not receive.

Section 8: Personal Appearances

Some artists achieve celebrity status and receive requests for paid speaking engagements. This provision covers income from such requests.

> 8) PERSONAL APPEARANCES. The Syndicate will act as the Producer's nonexclusive representative in connection with requests for personal appearances or personal services by the Producer, such as lectures, speaking engagements, television or other media appearances, or advertising, product endorsements, and the like, and the Syndicate will not arrange any such appearances or services for the Producer without first securing his approval, which he will not withhold unreasonably. The Producer will notify the Syndicate promptly of his approval or disapproval of the terms of appearances or services submitted to him. The Producer will pay to the Syndicate 20 percent of all amounts, after deducting therefrom his direct and necessary expenses incurred, which he receives for any such personal appearances or services, such payments to be made promptly after receipt of such amounts by the Producer.

Not all syndicate contracts overtly cover the contingency of income from personal appearances and personal product endorsements. One reason is probably that only a very small number of artists receive requests for paid appearances, and those paid appearances which are requested are low-paying. This is particularly true for cartoonists, whereas text writers may be famous in other arenas and, therefore, able to command significant speaking fees.

Since there is very little money at stake for cartoonists and usually for text writers, the syndicates accord such a provision either little to no attention. The significant money in appearances and endorsements is earned through direct association with the feature and its characters. For example, Met Life pays for Snoopy's endorsement, not that of Charles Schulz. One important ambiguity is how much an artist may refer to his feature in any endorsement without it becoming an endorsement covered by the syndication contract. For example, would the following endorsement by Scott Adams be a personal appearance or a use of "Dilbert"? "Hi, I'm Scott Adams, artist of the 'Dilbert' comic strip. I urge you to buy the 'Zap Your Boss' video game and strike a blow for the cubicle class." Different artists and different syndicate executives could legitimately answer either way.

Defining the limits of an artist's reference to his feature can eliminate such ambiguities. The fair limit seems to depend on what is being promoted: media opportunities or product endorsements. Media appearances help to publicize the feature, and so the artist should be permitted to mention his artist status, discuss the comic, and display samples. Product endorsements, however, may compete with the syndicate's work, so the artist should be limited to a simple announcement of his status as artist of the feature and should not be permitted to endorse anything too closely related to the feature (i.e., the "Zap Your Boss" video game mentioned above would not be allowed, but Florida orange juice would be).

The fact that the syndicate only requests "nonexclusive" representative status makes sense, because the contract covers only the feature and not the artist. Moreover, the syndicate is unlikely to want to take on exclusive agent responsibility for the artist's career. The main effect of this provision is that when the syndicate receives a phone call requesting the artist's service, the syndicate receives 20 percent of the net in exchange for administering the transaction. Unlike agents, the syndicates do not seek out such opportunities, but merely respond to offers. One downside to this provision is that a very successful artist who hopes to earn money through personal appearances will probably want to hire an agent to actively promote the artist's career. Such agents will prefer to work on an exclusive basis, so the nonexclusive status granted to the syndicate will prove an irritant to the agent. It may also be in the artist's best interest to let the agent manage all possibilities, so that a publicity strategy can be developed. Overall, for the Scott Adams–level stars, it would be better for the syndicate to refer any calls about personal appearances to the agent. For the vast majority of artists who do not expect significant personal appearance opportunities, granting nonexclusive representative status probably make sense, to encourage the syndicate to pursue and document the rare opportunities that become available.

It is unclear why Universal inserts the *"he will not withhold unreasonably"* language. One reason might be that publicity helps to sell the feature, which benefits the syndicate. Also, the syndicate stands to earn a 20 percent commission. Perhaps one effect is to encourage shy artists to do what they might not do if they were not contractually bound. On the other hand, an artist has a strong moral claim to protect his privacy. Further, it is very difficult to determine when the artist is withholding approval *"unreasonably."* To some artists, flying across the country might be an unacceptable burden, whereas other artists might see the trip as a free vacation. Overall,

it seems to make sense to keep the language, but permit the artist to be the final judge of whether or not he is being *"reasonable."*

Fair language incorporating each of the section 8 concerns discussed above might look like one of the following two options, the first of which is for artists with agents:

> *8) PERSONAL APPEARANCES. The Syndicate shall refer to the Producer or his agent all requests for personal appearances or personal services by the Producer, such as lectures, speaking engagements, television or other media appearances, as well as product endorsements. In connection with lectures, speaking engagements, and television or other media appearances, the Producer may refer to the Feature and use samples of the strips (columns) or merchandise. In connection with product endorsements, the Producer may refer to his status as artist of the Feature, but may not make other references or use samples without the permission of the Syndicate. The Syndicate may condition such permission on payment of a licensing fee under Section 3 as if the Producer were a third party.*

The language of this first option frees the artist from the syndicate, but limits the artist's ability to use the feature outside of the contract.

The second option probably serves better the majority of artists who have no outside agent.

> *8) PERSONAL APPEARANCES. The Syndicate will act as the Producer's nonexclusive representative in connection with requests for personal appearances or personal services by the Producer, such as lectures, speaking engagements, television or other media appearances, as well as product endorsements. In connection with lectures, speaking engagements, and television or other media appearances, the Producer may refer to the Feature and use samples of the strips (columns) or merchandise. In connection with advertising, product endorsements, and the like, the Producer may refer to his status as artist of the Feature but may not make other references or use samples without the permission of the Syndicate. The Syndicate may condition such permission on payment of a licensing fee as if the Producer were a third party under Section 3. The Syndicate will not arrange any such appearances or services for the Producer without first securing his approval. The Producer shall not withhold such approval unreasonably, but Producer's determination of reasonableness shall be conclusive. The Producer will notify the Syndicate promptly of his approval or disapproval of the terms of appearances or services submitted to him. The Producer will pay to*

the Syndicate 20 percent of all amounts, after deducting therefrom his direct and necessary expenses incurred, which he receives for any such personal appearances or services, such payments to be made promptly after receipt of such amounts by the Producer.

By clarifying the parties' rights, both options offer substantial improvement over the existing provision.

Section 9: Term and Termination

The term and termination provision of a syndication contract is *extremely important.* In fact, aside from the ownership of the feature's copyright, the term and termination provision is the most important section of the contract.

9) TERM AND TERMINATION. (a) The term of this agreement shall commence on the date hereof and end on the date ten calendar years from the date of first publication of the Feature in a newspaper, except that such term shall be automatically renewed for an additional period of ten years if the Syndicate's gross weekly billings during the first six months of the last year of the original ten-year term for the sale of the Feature and other rights granted pursuant to this agreement average at least $.

There are two giant issues here. The first issue is the ten-year length of the contract. Over the last decade, contracts have been reduced to approximately seven to ten years. Artists generally argue that long contracts are unfair, because they tie the artists to harsh deals signed when the artists were unknown and without bargaining power. Syndicates and even some artists counter that syndicates invest heavily in launching and selling each feature, so they must be allowed to recoup that investment over time.

While most artists agree on the concept of allowing syndicates to earn a fair rate of return on their investment, many feel that the syndicates' investment, while significant, is nowhere near as large as they claim. In fact, both parties are correct, but miss the bigger hidden dispute.

The hidden dispute is over who should subsidize the cost of the approximately 75 percent of features that cease publication within five years at an almost total loss to the syndicate. Even though the syndicates release no detailed analysis of their finances, it is obvious that the bulk of their profit comes from the blockbuster features, like "Dear Abby," "Dilbert," and "Peanuts" (and, even more specifically, from the licensing deals for those features). One high-level executive of a major syndicate stated, "syndicates are very profitable, but 90

percent of the features aren't that profitable." Since the syndicates' main hope with each release is that they have found the next block-buster, the nonblockbuster artists can make a credible argument that the syndicates should pay for the search for new blockbusters through the massive profits earned from existing blockbusters. The blockbuster artists, in turn, can argue that they should not be forced to subsidize anyone.

Another important factor to artists in determining an accept-able term length is the amount of work that the syndicates do over the course of the contract. Artists almost universally complained that once their feature's first year sales campaign ended, the syndicates ignored their feature and moved on in search of the next blockbuster. One syndicate executive even stated that they are just throwing fea-tures "against the wall to see what sticks." This makes sense from a business viewpoint. The syndicates' goal is to get the feature into enough newspapers so that the artist has a chance. In the end, a fea-ture must sell itself, and the syndicates do not want to put the time into salvaging a weak feature. Under this business strategy, it may take blockbusters a little longer to separate themselves from the pack, but very few are likely to actually cease publication if the syn-dicate created at least a moderate initial business. From an artist's standpoint, however, this lack of follow-up effort means that he wants a shorter contract, so that he can get the new publicity push that usually accompanies a re-signing or switch of syndicates.

Another factor affecting the term and termination of a syndi-cate contract is the odd fact that almost all of the strips and columns that survive are profitable, even the small ones. The 70/30 or better percent split major artists sometimes receive in contract renewals indicates that the marginal cost of servicing existing newspaper clients is less than 30 percent of gross revenue. Generally, in fact, it is believed that 10 percent covers a syndicate's overhead. The block-busters are wildly profitable and pay for both their costs and the costs of all the failed features that were introduced in the search for the next blockbuster.

A related issue is that at the time when they sign the initial contract, most artists are risk averse—they would probably be will-ing to earn a little less should they produce a blockbuster in return for earning more if they produce a feature of only average success. This compromise can be accomplished through manipulation of the term of the contract. The income hurdles that are typical of syndica-tion contract option provisions are so low as to be essentially auto-matic extensions. By instead granting the syndicate an option only

based on a very high hurdle rate of income, the artist agrees to receive 50 percent (rather than, say, 70 percent) for several extra years in the event that the feature becomes a blockbuster. This means that the blockbusters are subsidizing the average strips. This accomplishes the goal of artists pooling the risk in order to increase the median income. If done correctly, this provision could be profit-neutral for the syndicates. Such a provision might look like this:

> 9) TERM AND TERMINATION. (a) The term of this agreement shall commence on the date hereof and end on the date seven calendar years from the date of first publication of the Feature in a newspaper, except that such term shall be automatically renewed for an additional period of five years if the Syndicate's gross weekly billings during the first six months of the last year of the original seven-year term for the sale of the Feature and other rights granted pursuant to this agreement average at least $300,000 when annualized.

All of the above numbers are subject to negotiation, but this appears like a fair compromise, in line with industry standards, other than the extremely high hurdle.

Renewing artists are in an entirely different position than beginning artists, especially when negotiating the term and termination of the new contract. Renewing artists have a track record and an existing block of business. Thus, there is much more information, a stream of income, and (possibly) competition among the syndicates. Conceivably, the artist is now paying the syndicate for two different tasks: servicing existing clients and selling to new clients. Artists often argue that these services should be unbundled (i.e., vary the percentage according to the task) rather than bundled (pay the same percentage for existing and new customers). Under the artists' proposal, the syndicate would get a minor servicing fee (say 20 percent) on existing clients, but a large percentage (say 70 percent) on all new sales for several years. The term of the contract is then set at the number of years, which repays the syndicate's investment with a reasonable rate of return. Syndicates strongly dislike such unbundling. They prefer to view themselves as partners with the artists, and unbundling makes them feel like they are being turned into mere servicing organizations. Also, from a practical standpoint, unbundling also annoys the syndicates, because it makes them much easier to monitor. This means that the syndicate must constantly prove itself for each of its main activities. While this accountability might actually encourage improved business practices that increase

their long-term profitability, the syndicates follow most other businesses in preferring to insulate as many decisions as they can from market pressures. Straight bundling is the syndicates' preference. Here, as with new artists' contracts, the syndicates get a flat percentage. At the traditional 50/50 split, a term of five to seven years would probably reimburse the syndicate the cost of the sales campaign and provide for a reasonable profit.

The second, and vastly less significant portion of the term provision, is that both the contract and the artist's work commence well before the beginning of publication in newspapers. This uncompensated prepublication period of from three months to over a year results in an additional duration for the contract. Arguments as to its reasonableness cut both ways. This prepublication period includes time for the artist to hone the feature and for the syndicate to presell it to newspapers. However, it is possible that a syndicate might delay the launch date solely to fit its scheduling needs. In fact, in the early 1980s, United Media reportedly had three new features signed, including "Calvin & Hobbes." Since a syndicate usually only launches one comic feature at a time, United Media conducted a focus group with the goal of determining the most promising strip and then launching it first. The focus group "dumped on 'Calvin & Hobbes'," and so it was scheduled to be released last among the three strips. Thus, the introduction of "Calvin & Hobbes" was delayed many months, even though it was ready from an artistic standpoint. Bill Watterson was unhappy at the delay, so he took "Calvin & Hobbes" to Universal Press Syndicate.

Finding a slot on the syndicate's release schedule is not just a question of meeting the syndicate's legitimate needs. It is also a question of making sure that the syndicate is able to put its selling organization fully behind each new feature. If features are launched too closely together, they may cannibalize each other. Although some artists may view the syndicate as causing its own scheduling problems by launching too many features, that is a completely different discussion. Overall, it is probably in both the syndicate's and artist's best interest to grant the syndicate this extra time. Note, however, that many other syndicates start the contract term at the time of signing, so the issue is an open negotiating point.

The next provision provides both the syndicates and artists with a way to terminate the contract if the feature is failing.

(b) Beginning with the thirteenth month after the date of the first publication of the Feature in a newspaper, if the aggregate payment

to the Producer (prior to any deductions pursuant to Sections 4 and 7) under this agreement during any calendar month averages less than $ per week, either the Producer or the Syndicate may cancel this agreement upon at least 30 days notice to the other, given within the month following the month of such occurrence.

This is a reasonable provision. Note that the dollar figure per week tends to be far below that of a decent living wage. As one artist stated, the syndicates can make money at $300 gross billings each week, but the artist cannot. Artists need to decide for themselves what the minimum should be. Some artists may want a low minimum, so that they can keep doing a feature they love or believe in. Other artists may wish a higher minimum, so that they can take their feature and ideas elsewhere if the syndicate does not generate a list of clients that can support the artist.

Syndicates often request a provision that will allow them to make sufficient payment advances to keep the Producer in production even if the feature has a slow start.

Should the Producer elect to so terminate, the Syndicate may continue this agreement by advancing to the Producer a sum equal to the difference between $ and the aggregate payments due to the Producer (after any deductions pursuant to Sections 4 and 7) for the month upon which such election is based.

As mentioned above, syndicates can make money at a lower level of gross billings than the artist can. One reason the syndicates want a low figure as the termination is so that any payments under this provision are lower. This provision is reasonable and common to all syndicates. If the syndicate is optimistic or believes the artist is unduly pessimistic about the future of the feature, the syndicate should be allowed to keep the feature going long enough to have a fair chance of establishing itself and earning back the syndicate's start-up investment. So long as the payment amount is not set too low, both parties stand to benefit. The one clarification needed is the amount of time that the syndicate has to decide whether it wants to make the payment. If the syndicate could wait until the last day of the thirty-day period, then it would be impossible for the artist to sign with another syndicate or prepare for the transition of administrative responsibilities. Thus, the syndicate should be limited to a five-business-day window in which to make the decision on whether to make the supplemental payments, and thereby keep the artist on staff. The provision would look like:

Should the Producer elect to so terminate, the Syndicate may continue this agreement by advancing to the Producer within five business days a sum equal to the difference between $ and the aggregate payments due to the Producer (after any deductions pursuant to Sections 4 and 7) for the month upon which such election is based.

This change clarifies a possible ambiguity. This helps both sides, since the possibility of litigation over the reasonableness of a syndicate's response time is removed.

Most, but not all syndicates explicitly limit repayment for such advances to future income under the agreement.

and repayment of any such advance shall be made solely from subsequent payments due the Producer hereunder.

Both here and elsewhere in the contract, artists should insist on limiting any downside to the termination of the contract. This means that the syndicate should not collect negative balances from the artist if the feature is terminated. Artists need to watch this issue carefully, since most features fail, and costs can add up quickly.

Although the syndicate wishes to have the right to keep the feature going, the syndicate also wants to prevent any legal claim of reliance by the artist, as the next provision states.

No such advance shall constitute a waiver of either the Producer's or the Syndicate's right to cancel upon subsequent recurrences of the contingency provided for herein.

This provision recognizes that in the business world, transactions are often carried on without specific contracts or in violation of contract provisions. This is relevant here, because the law states that under certain circumstances, a later course of dealing between two parties can override preexisting contract provisions. By including this provision, the syndicate reduces the artist's ability to use arguments such as, "I relied on the syndicate's waiving of termination." This provision, therefore, simply clarifies the agreement and gives notice to the artist. Therefore, it is fair.

Once the contract ends, a set of very complicated post-contract rights spring into existence.

(c) Upon any termination of this agreement, whether by expiration or otherwise.

This introduction merely recognizes that the contract may end by the finishing of the term, by cancellation for not meeting income hurdles, or by other reasons, such as bankruptcy.

Depending on its interpretation and operation, the next provision may be the most potentially abusive one in the entire contract.

> (i) If there are at the time of such termination any outstanding contracts to third parties respecting any rights hereunder, the Syndicate shall continue to receive the proceeds therefrom, and shall make payments to the Producer in accordance with Section 7, until such contracts are terminated. Section 9(b) shall not be applicable.

This provision can be read to grant the syndicate the power to make third-party licensing (or even newspaper) contracts that extend beyond the scheduled termination of the syndication contract. Under this reading, the syndicate can grant a twenty-year license in the last year of the syndication contract and thereby effectively grab an extra twenty years of licensing income. It appears that this is the syndicate's interpretation. For those features with substantial licensing income, such a provision can dramatically undercut the advantage to obtaining the copyright at termination of the syndicate contract. On the other hand, without such a reading, the syndicate has little incentive to make attractive long-term licensing deals near the end of a contract. The obvious way around such a dilemma is for the artist to authorize the longer licensing contract on a case-by-case basis. Although the syndicate might fear that the artist and licensee will strike a side deal, this should be only a moderate concern: Since many licensing deals are time-pressured, the syndicate is unlikely to have many cases where an artist holds out an extra year or two just so that he can strike a better bargain after the syndication contract ends.

A more restrictive reading of the provision allows the syndicate to license through the scheduled end of the term. In the event of an earlier termination, the longer contracts are still valid. It is unlikely that the syndicate had this in mind when drafting the provision.

The artist should attempt to rewrite section 9 in order to remove any ambiguity. Ideally, a middle ground should be struck between the two possible readings. Reasonable language might look as follows:

> (i) If there are at the time of such termination any outstanding contracts to third parties respecting any rights hereunder, the Syndicate shall continue to receive the proceeds therefrom and shall make payments to the Producer in accordance with Section 7 until such contracts are terminated. Section 9(b) shall not be applicable. Provided, nevertheless, that such right shall not extend past the initial term of the agreement together with any renewal right.

Licensing through the end of the renewal period shall be pre-
sumptively valid even in the event that the Syndicate does not
eventually qualify for or exercise such right.

Although somewhat of a compromise, the syndicate is giving up more. Basically, the syndicate gets licensing income after termination if that termination occurs early, such as for failure to meet income hurdles, death of the artist, or bankruptcy of the artist.

The following final provision of section 9 is also subject to both an expansive and a limited interpretation, with the expansive one reclaiming much of the value of the copyright for the syndicate:

(ii) The Syndicate shall have the exclusive right to republish or cause republication in any media of all material delivered to it during the term of this agreement, provided that payment is made to Producer with respect to any republication in accordance with Section 7. Section 9(b) shall not be applicable.

The syndicate probably intends an expansive reading that defines "republication" as any reuse of the strip. Thus, reuse might include greeting cards, books, coffee mugs, calendars, and everything else that uses the feature. This becomes a permanent licensing right for a large part of the possible merchandise. Only such goods as stuffed animals, product endorsements, and the like are ruled out by the provision. Any such permanent licensing right should be at the top of the artist's list of topics for negotiation. The limited interpretation is that the syndicate may sell reprints and publish anthology books, but not license a strip for a coffee mug.

The following revision makes clear that the limited interpretation holds:

(ii) The Syndicate shall have the exclusive right to republish or
cause republication of the Feature delivered during the term of this
agreement in any anthology book, provided that payment is made to
Producer with respect to any republication in accordance with
Section 7. Section 9(b) shall not be applicable. All other uses of the
material delivered to the Syndicate shall revert to the Producer.

This is a much cleaner organization for the contract.

Clearly, a sizable portion of the value of the copyright is at stake in subsections (c)(i) and (c)(ii). Now that syndicates often allow artists to keep the copyright, the syndicates have become very subtle at carving out the key rights. Although syndicates use different language, all carve wherever possible. Of course, carving out rights

is sometimes a fair way of allocating value. For example, if the syndicate grants a very short initial term, such as five years, that syndicate might fairly require the artist to pay over some of the revenue earned in subsequent years. An increasing number of syndicates follow this approach.

The lesson for artists is to focus on any section that addresses posttermination rights and duties. Not all such provisions are unreasonable, but most are very important.

Section 10: Assignment, Etc.

Section 2 permits the syndicate to delegate to third parties any of its duties, as well as to assign any of its rights. Section 10 goes further by permitting the syndicate to completely assign the contract to a third party.

> 10) ASSIGNMENT, ETC. This agreement shall be binding upon and inure to the benefits of the parties hereto and their respective heirs, legal representatives, successors, and assigns, except that this agreement may not be assigned by the Producer except (a) to a corporation formed by the Producer of which all of the voting stock is owned and continues to be owned by him, and (b) where the Producer continues to be the person who prepares the Feature.

The right to assign the contract means that the syndicate can sell anywhere from one contract to its entire portfolio (essentially, the power to sell the company). As with the similar provision in section 2, the syndicates are likely to feel so strongly about this provision that almost all artists will be unable to negotiate substantial assignment restrictions. Still, there are several issues that need further examination and clarification.

With regard to selling the company, any syndicate that has granted approval rights to the artist faces both a possible legal block to the sale or, if the sale is allowed to go forward, a possible major reduction in the value of the business. The legal block is that an artist approval right is a flat veto power under most circumstances. The veto power arises because the syndicate has no right to terminate the agreement unless there is either a breach of the contract by the artist or a shortfall in revenue pursuant to section 9's term and termination provision. Rewriting the contract to permit the syndicate to terminate the contract of any nonconsenting artist would not help much, as almost all of a syndicate's value is attributable to its sales network and its long-term contract rights with profitable artists. Thus, it would destroy most syndicates if all of their artists

became "free agents" as a result of a sale of the business. Overall, the only individuals who stand a chance of getting approval rights would be blockbuster artists in small syndicates. Since such an artist really *is* the syndicate, he may be able to convince them that it is better to take the chance of him destroying its economic value in the future than to drive him away now, which makes the feared future a current certainty.

One compensating aspect of the syndicate's transfer right is that sometimes the change is good for the artist, especially for artists tied to harsh contracts and intransigent syndicate management, when the business is sold to a more accommodating owner. Bil Keane, for example, is reported to have struggled in vain for many years to regain his copyright to the comic strip "The Family Circus." When his syndicate was purchased, he inherited a more receptive management and negotiated the return of his fundamental artist rights. The reverse problem of moving from a good syndicate to a bad one is less of an issue if the artist has already secured basic contract rights, such as copyright ownership and a moderate term.

With regard to assigning one or just a few contracts, the syndicate has similar concerns as with a sale of the business. Here, however, the veto power or ability to get out of the contract is likely to be less important for two key reasons. First, the transfer of such contracts on an individual basis is a rare event, so nontransferability is unlikely to have a significant impact. Second, in the instances where individual transfers are made, the circumstances tend to be extraordinary. The most likely scenario is that the artist becomes dissatisfied with the existing syndicate and wants to move to a different one. In such cases, the artist may well push for the move rather than resist it. As with the syndicate's power from section 2 to delegate rights, the best remedy for ownership or personnel problems for the artist is to own his copyright and have a short enough term on the contract to permit escape within a reasonable number of years. Overall, Universal's provision reflects its needs fairly.

At least one syndicate provides the artist with a consultation right. This right merely obligates the syndicate to inform the artist prior to an assignment of the contract; the artist has no approval authority. This provision seems unhelpful to the artist and potentially hazardous to the syndicate. Although it would seem that consulting with artists would be a good client-relations move and perhaps smooth the transition, in fact, most buyout or merger discussions need to take place in absolute secrecy. For the sale of individual contracts rather than of the syndicate's entire portfolio, such a consul-

tation right makes more sense for two reasons. First, from a logistic standpoint, it is more feasible to provide meaningful meetings between syndicate personnel and a couple of artists than with fifty or more artists, all of whom may have a significant number of questions. Second, the sale of just a couple of contracts is unlikely to generate the attention that the sale of a whole syndicate would: Fewer people are involved, and it is less newsworthy. Still, although the issue is less dramatic for the sale of individual contracts, in both cases, the decision should probably be left to the syndicate executives as to when and how they should inform the artists.

The one clear case where the artist deserves the right to know of a potential sale is when the artist is negotiating for a contract renewal. In the interviews conducted for this review, many artists stated that their decision to stay or move to a new syndicate was based primarily on their syndicate's size and personnel. It would be unfair for a syndicate to manipulate the timing of a sale of the company or a renewal of a contract because some blockbuster artist's contract was in renewal negotiations. Further, such manipulation might be perpetrated by a third party who knew about major contracts within the syndicate. A good, though still imperfect, solution to the artist consultation right issue might look as follows:

> *Prior to the assignment of this agreement, the Syndicate may consult with the Producer and any or all other entities with which the Syndicate has contractual relations. Provided, however, that the Syndicate shall not be required to so consult. In the event that the agreement with the Producer is assigned within three months of any extension or renewal, the Producer may terminate the agreement within 30 days if he had not been notified of the potential transfer prior to the extension or renewal of his contract. The Producer shall have this right whether or not the Syndicate was engaged or planning such negotiations at the time of the signing of the renewal or extension. The Producer agrees to hold confidential any information learned pursuant to this paragraph.*

This provision clarifies that the syndicate may consult with certain artists without being accused of legally inappropriate favoritism. The syndicate may also keep the discussions secret if it is worth releasing the artist from his contract at the time of a contract renewal or extension. A large syndicate like King Features might well choose this option if it were merely re-signing a couple of smaller features. Not only is the amount at stake in such situations low, there is also a reasonable chance that the artist will continue with the contract unless he is truly aggrieved.

Section 11: Book Publishing and Licensing

The potentially rampant conflicts of interest in the following book publishing and licensing provision are actually fewer than they appear.

> 11) BOOK PUBLISHING AND LICENSING. The Syndicate is affiliated with a book publishing firm, Andrews & McMeel ("A&M"), and with a licensing firm, Universal Licensing, Inc. ("ULC"), and the Syndicate may (but need not), pursuant to rights granted it by this agreement, contract with either A&M or ULC for publication or other uses respecting the Feature. In this connection, the Syndicate will not so contract with either affiliate except on terms which (a) considering all circumstances, in the Syndicate's reasonable judgment are as favorable as could be obtained from an unaffiliated party, and (b) provide creative control to the Producer and the Syndicate. Receipts by the Syndicate from either affiliate pursuant to any such contract will be subject to the payment provisions of this agreement.

Andrews & McMeel is the premier publisher of comic reprint anthologies, so the artist almost certainly wants A&M to publish a book of the feature. Furthermore, with books, both fair market payment and sales effort are somewhat easier to determine and monitor, since the active life of the book is short, whereas syndication efforts occur over many years.

Compared to A&M, Universal Licensing is less dominant in its market and harder to monitor, so the risk is higher and the payoff lower. Overall, the question is one of business judgment regarding conflicts of interest.

The only legal issue is the "reasonable judgment" standard. Given that there are so many obvious possibilities for conflicts of interest, the syndicate is justifiably concerned with being accused of inappropriate behavior. This "reasonableness" standard provides the syndicate with some protection against disappointed artists who may claim a conflict of interest even where the transaction was legitimate. Thus, it appears to be a fair standard.

Section 12: Time of Delivery

Syndicates need lead time to prepare a feature for distribution. Common deadlines for comic features are six weeks in advance for dailies and eight weeks for Sundays.

> 12) TIME OF DELIVERY. The time of delivery of installments of the Feature shall be set forth below or, if no time is specified, such delivery shall be as is reasonably specified by the Syndicate from time to time.

Syndicate executives prefer the installments as far in advance as possible, whether for efficiency of the syndicate's operation, for the executives' peace of mind, or both. By contrast, artists generally prefer shorter deadlines. The real problem for artists, however, is not what the deadline is, but rather the fact that it constantly looms over them. As Wiley Miller of "Non Sequitur" put it, "In this kind of work, it is not that the deadlines are so immediate, it's that they are inaccessible. They are always going to be there, seven days a week, fifty-two weeks a year."

On the other hand, a few strips such as "Doonesbury" and "Mallard Filmore" reflect current events and need as short a deadline a possible. Furthermore, some artists have difficulty motivating themselves far in advance, especially on material topical to some future time of the year.

"There just isn't any way I'm going to be able to do Christmas cartoons in July," said one artist. "It's tough enough in November." Artists need to judge on an individual basis whether the specific deadline matters enough to negotiate some control.

The next provision provides the remedy for late submissions.

> Time is of the essence as to this Section, and Section 4 contains certain provisions for deductions for costs occasioned by Producer's failure to meet delivery times.

Under general contract law, the stock phrase *"time is of the essence"* can encourage timely performance in two ways. If the party under the time-sensitive obligation fails to perform, then the other party is either excused from counterperformance, has a claim for breach of contract, or both. In the case of the Universal contract, however, section 12's *"time is of the essence"* provision is used to trigger section 4's remedies. This is an interesting twist on general contract law, because section 4 does not claim to either terminate the contract or even make the artist liable for damages due to nonperformance. In fact, the syndicate's remedy is the right to perform the artist's duties. The only penalty is that the syndicate may subtract any related costs from the artist's earnings. This odd situation is explainable by the nature of the contract: Syndication contracts are valuable because they are long-term arrangements that generate a steady income stream with only minor work for the syndicates after the cost of launch.

Section 13: Product Agreement

Almost all syndicate contracts require that the artist acknowledge his status as an "independent contractor" rather than an "employee."

13) PRODUCT AGREEMENT. Producer acknowledges that this agreement is not a personal services or employment agreement and that the Producer is an independent contractor and not an employee of the Syndicate.

Syndicates prefer the artists to have independent contractor status rather than employee status, because it reduces the syndicates' obligations. Specifically, the syndicates do not want artists as employees because 1) they would be subject to liability, 2) they would have to pay benefits, and 3) it's easier to get rid of artists if they are independent contractors. Thus, artists are denied the usual benefits of formal employee status, such as:

- Unemployment compensation
- Workers compensation
- Disability insurance
- Pay in accordance with the Fair Labor Standards Act (FLSA)
- Protection under the Occupation Safety and Health Administration
- Social Security and Medicare coverage (FICA)
- Coverage under the Americans with Disabilities Act
- Coverage under the Age Discrimination in Employment Act
- Coverage under the Family Medical Leave Act
- Rights under the National Labor Relations Act
- Coverage under the Review of the New Internal Revenue Service Initiatives Regarding the Independent Contractor/Employee Distinction or 1996

This list includes some major items. As one colorful artist put it, "I have worse employment status than someone who works at Wendy's." For example, the artist must pay the additional half of the FICA burden in order to make up for the fact that the syndicate does not contribute the employer half. Also, exemption from the FLSA means that an artist can, and many do, work for below minimum wage.

Agreement between the syndicate and an artist as to independent contractor status does not automatically guarantee that the IRS, other agencies, or the courts will view the relationship that way. These government bodies use various sets of objective criteria to make the determination of independent contractor/employee status, and how the parties label the relationship is only one factor. The most important set of criteria are the twenty common law factors that the IRS examines when determining employee status for federal tax purposes. The IRS uses these twenty factors as an analytic tool

in order to decide whether, on balance, the employer has the right to "direct and control" the person. If so, the person is likely to be held an employee. You should obtain additional information on independent contractor status at your local IRS office.

Many artists feel that the independent contractor provision is invalid. Such a conclusion depends on the artist's situation and the particular law involved. These examinations are beyond the scope of this discussion. However, initial research in the area appears to strongly support the syndicates' position on the issue, at least for IRS purposes.

Section 14: Governing Law

The following is a "choice of law" provision, and almost all commercial contracts have one.

> 14) GOVERNING LAW. This agreement shall be governed by the laws of the State of Missouri as to all matters including, without limitation, matters of validity, construction, effect, and performance.

Even the short syndicate contracts, which omit an express choice of law provision, insist that the contract be signed in a certain state, which is normally the syndicate's home state. Both the express provision and the hidden maneuver are attempts to control which law governs the contract.

Choosing the governing law benefits the syndicates, both from a pure law standpoint and from a convenience standpoint. From a pure law standpoint, choosing the governing law is an advantage, because the syndicate can know in advance how courts are likely to interpret each provision. This means that the syndicate can craft the contract to its best advantage. From a convenience standpoint, if there ever is a conflict with the artist, then the syndicate can defend or pursue the lawsuit more cheaply, because it is more likely that neither its executives nor its attorneys would need to travel or learn the law of another state. For precisely the opposite reasons, it is much more expensive for an artist to maintain a lawsuit using different law and possibly in a distant jurisdiction.

The fact that almost all commercial contracts contain choice of law provisions does not mean that they are always valid. For some issues and under some sets of facts, courts will refuse to recognize the choice of law and instead will use the law of the local jurisdiction. However, because state law varies so widely in its recognition of choice of law provisions, and because state law is often unclear as to its position on choice of law provisions, artists should consult with an attorney on an individual basis if an actual dispute arises with his syndicate.

Section 15: Miscellaneous

The "miscellaneous" provisions in this contract address a wide range of common legal issues.

> 15) MISCELLANEOUS. If there is more than one Producer, the term "Producer" herein shall mean all of them, their obligations under this agreement shall be joint and several.

Joint and several liability means that each artist is fully liable for the promises made in the contract. The syndicate may sue one or more of them for performance or damages.

> and any payment due them hereunder shall be equally divided among them unless they otherwise specify by notice in writing to the Syndicate.

An equal split of proceeds from the contract is a reasonable default rule.

> The section headings herein are for reference only and shall not be considered in interpreting this agreement.

This provision is merely an aid to the interpretation of the contract in the event of a lawsuit. Neither party is helped or hurt by it.

> The provisions of this agreement constitute the entire understanding of the parties hereto, and this agreement may not be amended, modified, or discharged except in writing.

This provision expresses two common protections: *"entire understanding"* and *"no oral modifications."* Both protections attempt to control how a court would interpret the contract.

The *"entire understanding"* provision is known as a "merger clause." The main benefit to such a provision is that a court will hold that the contract wipes out all prior negotiations, agreements, and understandings. This is yet another good reason for both parties to follow this paper's recommendation of writing down all terms of the arrangement, including the method of doing business, if that is important. A more comprehensive version of the provision might look as follows:

> *The provisions of this agreement constitute the entire understanding of the parties hereto, and supersede all previous negotiations, agreements, and understandings, whether written or oral, express or implied.*

This more comprehensive language means the same thing as what it replaces, except that it is much easier for artists to understand.

The next provision tries to prevent *"oral modifications,"* but is probably not enforceable in most jurisdictions. Under the common law, such provisions are generally invalid. One important factor in evaluating their validity is whether the party claiming such a modification has relied on the change in the contract terms. If so, the court is likely to be sympathetic. However, some states, such as New York, have enacted statutes that seemingly reverse the common law. Artists and syndicates should consult the law of their contract's jurisdiction to confirm the applicable law. Even if the *"no oral modifications"* provision is valid and disallows a claim that the deal was changed, the syndicate or artist might be able to pursue several related theories of law, such as the collateral agreement rule or promissory estoppel.

The next provision preserves the rights of either party, which may at some point during the contract make a limited waiver of rights.

> The waiver of any party hereto to a breach of any provision of this agreement shall not operate or be construed as a waiver of any subsequent breach by any party.

This provision is necessary, because the waiver of some rights in a contract can be more extensive under the law than the waiving party intended. In particular, a temporary waiver of a breach of the contract can become a permanent waiver under several legal theories. The effect of the no-waiver provision is to reduce the number of such legal defenses and to raise the standard for proving the remaining ones. In the end, however, a waiving party must be extremely diligent. Every time a significant breach or a continuing minor breach is waived, the waiving party should send a letter acknowledging the waiver, but insisting on the preservation of the right to enforce the contract term in the future.

The final part of the contract is the signature page.

> To indicate your acceptance of and agreement to the foregoing, please sign and return to us the enclosed copies of this agreement.

> Very truly yours,

> UNIVERSAL PRESS SYNDICATE

> By ————————————————

The foregoing is accepted and agreed to as of the date hereof.

(Producer)

(Producer's Social Security Number)

(Producer's Date of Birth)

It is standard practice for contracts to include a disclosure of the artist's date of birth and Social Security number. The syndicates need this information to report earnings to state and federal taxing authorities, as well as for immigration purposes.

Conclusion

The goal of this review was to provide syndicates, artists, and their attorneys with the information necessary to draft fair and efficient contracts. Many of the suggestions that, once articulated, seem like common sense have been overlooked until now, because few people had both the legal and business knowledge to make the obvious connections.

My greatest fear regarding this discussion is that syndicates may undermine its balanced approach. Since they have the lawyers and bargaining power, the syndicates may selectively adopt only those recommendations which help them. As a result, artists need to understand this document so that they can successfully prevent syndicates from overreaching.

Author Biography

Stuart Rees graduated from Harvard Law School in June 1997. The original version of this paper was written in satisfaction of his thesis requirement, although the current draft incorporates his subsequent experience in the negotiation of dozens of syndicate contracts.

Since June 1999, Stuart has operated his own entertainment law firm, with a substantial practice concentration in the fields of syndication and graphic arts. From September 1997 until June 1999, he worked as an intellectual property attorney for Bingham Dana LLP, a major Boston law firm.

Stuart is a lifelong fan of newspaper comics. As an outgrowth of this interest, he maintains an Internet site devoted to comic strips *(www.stus.com)*. This site offers funnies pages, search tools, original content, a bookstore, and descriptions of all online cartoons.

Stuart may be reached via e-mail at *stu@stus.com*.

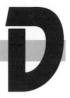

FORMS

I would like to thank Angela Adair-Hoy, president of Deep South Syndication, for providing the following sample letters and forms.

Sample Query Letter

ANGLING WITH ANGIE

Mr. Herbert Taylor, Editor
Galveston County Daily News
P.O. Box 628
Galveston, TX 77553

Dear Mr. Taylor,

I reek of fish. Dried, dead shrimp are wedged under my car seats. Sunscreen is my makeup of choice. Much to my neighbors' disgust, my 20-foot Lamar sits proudly on my front lawn. Trophy fish photos adorn my home. My walls resemble those of a profitable bait camp. Fish is served nightly here . . . fried, blackened, and (my personal favorite) barbecued.

When the fishing is slow, I sit on my boat, notebook and pen in hand, and record my angling adventures. I feel compelled to share God's gift of the sea and the sport of angling with our neighbors, your readers.

What do I charge? $5 per column. That's right. Same price as a pint of live shrimp, which is enough to get material for my next column. I'll provide your readers with how-to and where-to saltwater and freshwater fishing adventures, along with a tasty recipe now and again. Reader participation is always encouraged.

If you need to reach me, ask the marine operator to page The HardHead. My other contact information appears below.

You're welcome to come by for dinner anytime, or to meet me at 4:00 A.M. on any Saturday morning for a day of sore muscles and sunburn.

"Angling Angie"
a.k.a Angela Adair-Hoy
1006 S. Country Club
Shoreacres, TX 77571
Aadair@writersmarkets.com

Sample Spec Sheet

ANGLING WITH ANGIE

SCHEDULE: Weekly

LENGTH: 700 words

PURPOSE: To hook readers living on the Texas coastal bend with saltwater and freshwater fishing news, how-to/where-to, and suspense

DELIVERY: Fax, e-mail, or disk with hard copy

NEWS: True fish tales, record holders/breakers, humor, new product reviews

HOW-TO/WHERE-TO: Fishing, catching, rigging, boating, safety, conservation, secret fishing spots, honey holes, reader contributions, guide service interview/profile, tournament coverage

SUSPENSE: True, life-threatening situations on the water

RIGHTS: First print rights in your primary circulation area

Sample Author's Biography

ANGLING WITH ANGIE

Angling Angie (aka Angela Adair-Hoy) was a reporter for TV-10 in The Woodlands, Texas, prior to settling on the Texas Gulf Coast in 1987.

Angie's works have appeared in numerous magazines and newspapers and on several Internet Web sites. Her specialties are articles on writing and on outdoor angling adventures. Two of Angie's articles (with photos) appeared this month in *Gulf South Sailing* magazine and *AnglerSport* magazine.

Aside from her numerous freelance writing and publishing accomplishments, Angie has long held the Adair Family Shark Record with a 4-foot blacktip caught in Galveston. A trip to Costa Rica netted Angie a 65-pound Roosterfish, which was close to the world record at that time.

Angie provides professional 35mm photographs with all article submissions.

Angela Adair-Hoy
1006 S. Country Club
Shoreacres, TX 77571
Aadair@writersmarkets.com

Sample Contract

SYNDICATED COLUMN (CARTOON) SERVICE AGREEMENT

This is a service agreement ("contract") between Angela Adair-Hoy ("Creator") and the undersigned ("Client") executed by the Client on this, the ____ day of _____, 20__. The Creator is engaged in the service of syndicating written columns (cartoons) to print publications. The Creator will forward column (cartoon) packets two weeks prior to publication dates assigned by Client. The Creator is a contributing artist and will perform all service acts of delivery, fee and contract negotiations, billing and collections.

Client agrees not to rent, sell, provide, or otherwise dispose of any columns (original art) provided by Creator with the exception of one-time print rights being assigned by Creator as per this agreement. Additional distribution, print, and electronic rights may be granted by Creator, for an additional fee, upon written request by Client.

Client agrees to pay creator for services at the rate of $____ per feature, pursuant to this agreement. Payment for services rendered by creator shall be made by Client within thirty (30) days of date of invoice, payable to the Creator. Late payment charges will accrue monthly at the rate of 18 percent per annum on all past due balances exceeding thirty (30) days. Accounts sixty (60) days past due are subject to contract termination without notice.

This contract will continue on a month-to-month basis until either party shall have given the other thirty (30) days written notice of the desire to terminate this agreement, or under the nonpayment terms above.

This contract constitutes the entire understanding and agreement between the parties; it is subject to cancellation only as provided above, and it may not be altered or varied by oral agreement or representatives of any third party.

_____ _____
Angela Adair-Hoy Date
1006 S. Country Club
Shoreacres, TX 77571

_____ _____
John Doe Date
Editor
ABC Newspapers
223 South Street
Blue Ridge, KY 02994

Sample Client Information Form

CLIENT INFORMATION

Publication Name: _____

Authorized Representative: _____

Mailing Address: _____

Physical Address: _____

Current Circulation: _____

Phone Number: _____

Fax Number: _____

E-mail Address: _____

Internet Web Site: _____

Rate Per Feature: _____

Method of Delivery:

____ U.S. Mail (hard copy ____ disk ____)

____ Facsimile—Fax Number: _____

____ E-mail—Address: _____

REFERENCES

Cartoonist Profile
Jud Hurd, Editor
P.O. Box 325
Fairfield, CT 06430
A quarterly publication, costing $25 a year, with insights on cartoonists, advice for newcomers, industry information, tips, and more.

The Columnists' Collaborative
www.askbuild.com/tcc
A cooperative marketing group for writers.

Editor & Publisher
11 West 19th Street
New York, NY 10011
www.mediainfo.com/ephome/index/unihtm/home.html
Monthly magazine covering the publishing industry, including syndication. Cost is $75 for fifty-two issues. They also release an annual *Editor & Publisher's Directory of Syndicated Services (www.mediainfo.com/store/syndicat.htm)* and the *Editor & Publisher International Year Book (www.mediainfo.com)*, which offers a comprehensive listing, including telephone numbers, e-mail, and postal addresses, of key editors and newspapers.

National Cartoonists Society, Inc.
Columbus Circle Station
P.O. Box 20267
New York, NY 10023
www.reuben.org
Nationwide organization for the support and encouragement of aspiring cartoonists.

Newspaper Editor E-mail Directory
Featuring 800+ e-mail addresses of newspaper editors across the country (and a few international ones, too), this is an excellent resource for marketing your feature articles and/or self-syndicated columns. Cost: $19.95. Order online at: *www.writersmarkets.com / index-orderform.htm.*

http://rec.arts.comic.strips
Usenet newsgroup for cartoonists to discuss everything from the health of the industry to Pulitzer prize nominations.

Stu's Comic Strip Connection
www.stus.com
Excellent source of information on the cartoon industry, legal aspects, major syndicates, and professionals in the trade.

Syndicates E-mail Directory
Market your feature articles, columns, cartoons, puzzles, and more to syndicates around the world. This list of one hundred syndicates include top-named agencies like Creators and King Features as well as smaller, specialty groups. Cost: $19.95. Order online at: *www.writersmarkets.com / index-orderform.htm.*

US All Media E-mail Directory
www.owt.com / dircon
Names and e-mail addresses of key sub-editors in the United States.

Wisenheimer Bulletin Board for Cartoonists
www.tedgoff.com / wwwboard / wwwboard.html
Discussions on the state of cartooning and other information.

The Writer's and Photographer's Guide to Global Markets
A complete guide to selling features to markets around the world, including listings of newspapers, magazines, and editors. Cost: $23.95 (hardcover). Allworth Press, 10 East 23rd Street, New York, NY 10010 *(www.allworth.com).*

ABOUT THE AUTHOR

Michael Sedge is an American Society of Journalists and Authors director-at-large. For the past twenty-seven years, he has lived in southern Italy, where he owns and operates the Strawberry Media agency. Author of more than 2,600 articles and several books, this is his third title for Allworth Press. Sedge is also the Mediterranean/Middle East Editor of *Discovering Archaeology* and *Archaeology Traveler* magazines.

INDEX

Books from Allworth Press

Marketing Strategies for Writers by Michael Sedge (softcover, 6 × 9, 224 pages, $16.95)

The Writer's and Photographer's Guide to Global Markets by Michael Sedge (hardcover, 6 × 9, 292 pages, $19.95)

How to Write Articles That Sell, Second Edition by L. Perry Wilbur and Jon Samsel (hardcover, 6 × 9, 224 pages, $19.95)

Writing.com: Creative Internet Strategies to Advance Your Writing Career by Moira Anderson Allen (softcover, 6 × 9, 256 pages, $16.95)

The Writer's Legal Guide, Second Edition by Tad Crawford and Tony Lyons (hardcover, 6 × 9, 320 pages, $19.95)

Business and Legal Forms for Authors and Self-Publishers, Revised Edition with CD-ROM by Tad Crawford (softcover, 8½ × 11, 192 pages, $22.95)

Business and Legal Forms for Illustrators, Revised Edition with CD-ROM by Tad Crawford (softcover, 8½ × 11, 192 pages, $24.95)

The Complete Guide to Book Marketing by David Cole (softcover, 6 × 9, 288 pages, $19.95)

The Writer's Resource Handbook by Daniel Grant (softcover, 6 × 9, 272 pages, $19.95)

Photography for Writers: Using Photography to Increase Your Writing Income by Michael Havelin (softcover, 6 × 9, 224 pages, $18.95)

Please write to request our free catalog. To order by credit card, call 1-800-491-2808 or send a check or money order to Allworth Press, 10 East 23rd Street, Suite 510, New York, NY 10010. Include $5 for shipping and handling for the first book ordered and $1 for each additional book. Ten dollars plus $1 for each additional book if ordering from Canada. New York State residents must add sales tax.

To see our complete catalog on the World Wide Web, or to order online, you can find us at *www.allworth.com*.